W9-BUP-724

AMAZING MEN

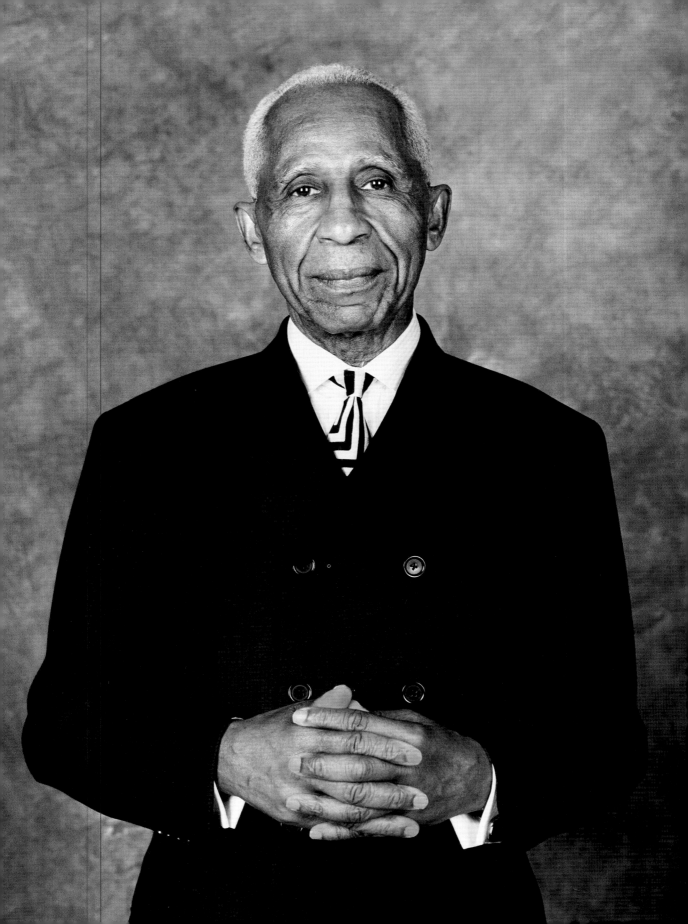

JOYCE TENNESON

AMAZING MEN
COURAGE • INSIGHT • ENDURANCE

BULFINCH PRESS

NEW YORK•BOSTON

Copyright © 2004 by Joyce Tenneson

All rights reserved. No part of this book may be reproduced in
any form or by any electronic or mechanical means, including
information storage and retrieval systems, without permission in
writing from the publisher, except by a reviewer who may quote
brief passages in a review.

First Edition
Library of Congress Cataloging-in-Publication Data

Tenneson, Joyce
 Amazing men : courage, insight, endurance / Joyce
Tenneson. — 1st ed.
 p. cm.
 ISBN 0-8212-2855-2 ISBN 0-8212-2902-8
 1. Photography of men. 2.Portrait photography—
United States. 3. Aged men—United States—Portraits. 4.
Tenneson, Joyce, 1945– I. Title.

TR681.M4T46 2004
779'.23'092—dc22
 2003061328
 Bulfinch Press is a division of AOL Time Warner Book Group.
For more information on Joyce Tenneson's work or *Amazing Men*,
 please visit her Web site at www.joycetenneson.com.

 Designed by Paula Davis and Miwa Nishio

 Frontispiece: Rev. Leon Troy, 77
Printed and bound by Amilcare Pizzi, Milan, Italy

DEDICATION

I dedicate this book to all of the wonderful men on these pages who allowed me to enter their private universes. The fact that they were all age sixty to one hundred made my journey even more of an adventure and a revelation.

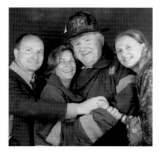

INTRODUCTION

Man has existed for perhaps a million to three million years. Until about ten thousand years ago, he led a precarious life in small societies. He lived primarily by fishing and hunting, and died in his twenties. Only about 10 percent of men survived until age forty. Primitive man was obsolete by that age. Tribes needed only a few older men of wisdom and leadership; more would have strained their limited resources.

Late adulthood, as we now know it, is the result of post-industrial advances. This large extension of life has often brought fear and anxiety: fear of impending weakness, vulnerability, and a life without meaning. There are few positive images of the older "hero," a man of dignity and wisdom. The work of this new life phase is different, involving greater responsibility and judgment in developing the culture morally, intellectually, and aesthetically.

Improving life in its last phase has been a recent topic of great interest in magazines and books. Some experts think that adult development and the huge new groups reaching later life will transform human society as we have known it. Fear has turned into curiosity. What does it look like to be an elder in the new millennium? What do men over sixty really think? Renaissance doctors believed it took a lifetime for one's true identity to emerge. The essence of each person was seen as individual as the stars. This sense of the sacredness of each person challenges us to look at our elders with new eyes.

Several years ago I published *Wise Women*, a book of portraits of women sixty-five to one hundred years of age. I have been amazed by the response. People from all over the world write and e-mail me daily to let me know their reactions to the book, and to tell me their own stories. Many asked me when I would be photographing men in the third phase of their life. They wanted to know more.

I decided to travel around the country to cities and towns as diverse as Miami, Las Vegas, Columbus, Ohio, Big Fork, Montana, and Portland, Maine. I photographed and interviewed over one hundred fifty subjects.

It has been fun. I loved working on this book: I was surprised, entertained, challenged, and uplifted. Some men were sexy and clever and playful, others were physically fragile, others luminous with old age. All made me see the complexity of aging in new ways. I trust these visual and verbal portraits communicate their own rich stories.

Life etches itself into our faces. There are fewer secrets as we near the end of our journey. The need for a façade of outer power fades. In the end, we are all left with who we truly are; we realize that there is no way to escape getting older, no way to escape death. As I traveled around the United States to photograph, I heard many stories. I would like to share some of the memorable experiences and anecdotes I've collected while working on this book.

I went to the celebrated cartoonist Al Hirshfeld's house and walked up four flights of stairs to his studio (p. 37). At age ninety-nine he was still sitting at his drawing board working on an assignment for *The New Yorker*. He was as mentally agile as my young assistant. He told me that he was really a portraitist; he loved getting the ultimate gesture of his subjects, something that summed up their quirky, individual natures. Six months later I photographed his friend, the painter Paul Jenkins (p. 36), who had planned to have dinner with Hirshfeld the night after he died. I sat for a long time talking with Paul about how much he missed his dear friend. Paul had lost so many friends and family in his eighty years, just communicating with him made me feel the mysterious nature of profound loss in life.

In Miami, I rented a studio and asked all of my friends and former students to suggest men from their international communities whom I could photograph. I met seventy-two-year-old Alberto Menendez (p. 68). He came with his guitar and a flamingo-patterned shirt and stayed with us all day helping put everyone else at ease. A Haitian guitarist came later in the day and they created songs they could sing together. Tom Gonzalez asked me to photograph him with his eighty-three-year-old father (p. 84), who was struggling with Alzheimer's disease. Thomas Sr. seemed to be in his own universe until his son encircled him with his arms. This was a rare look at father and son and how the role of caretaker shifts over time from one to the other. The same day, a young woman who had e-mailed me a beautiful letter after reading *Wise Women* came to meet me with her grandfather, Simon Rensin (p. 62). He had left Russia during the 1919

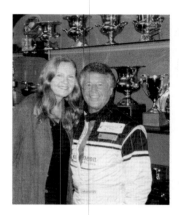

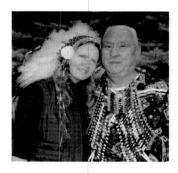

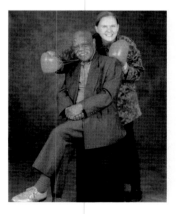

Top: Joyce with Mario Andretti in his trophy room in Pennsylvania.
Middle: Joyce with Octave Finley in Montana.
Bottom: Joyce with Doc in Las Vegas.

Top: Joyce with Robert
Indiana in Maine.
Middle: Joyce with Khing Oei
and Jeanie MacPherson in
New York.
Bottom: Joyce with Patrick
Stewart and David Jones in
New York.

revolution, walking and hiding for a year and a half until he
finally reached Poland. Venezuela became his next home of
exile. That morning he had gone to a rabbi to ask about the
Spanish prayer for Passover. He also mentioned that he regretted
never having had a Bar Mitzvah. The rabbi performed the
ceremony, admonishing that it is never too late.

Next, two domino players came to be photographed (p. 41).
As they were leaving they told me that they played every day from
8:00 a.m. until 3:00 p.m. I learned that dominoes can be a form
of meditation as it focuses their minds and they become lost in
that universe. Nothing else distracts them for those hours of bliss,
away from their day-to-day problems and close to their Cuban
heritage.

In Columbus, I spent a glorious day working with students from
the Columbus College of Art and Design. The school put together
a schedule of amazing men from their community, from a CEO to
an eighty-year-old member of the original Tuskegee Airmen. It
was a marathon session of interviews and portraits with students
acting as my assistants.

Las Vegas was my next stop, a town built on casinos and
façades that draws people from diverse backgrounds. Doc, age
eighty-three (pp. 12–13), came in his training outfit. He said
that he always trains young boxers to see their potential. He
said, "Dreams and inspirations arise of their own accord, like
springs and rivers."

We drove to Nazareth, Pennsylvania, to meet racecar legend
Mario Andretti (p. 93). He invited my assistants to view his
personal sports bar, trophy room, and wine cellar. He chose a
special bottle of wine as a gift for each of us.

I made arrangements to meet eighty-six-year-old painter Andrew
Wyeth in Maine (p. 123). He pulled up in his boat at the public
landing in Port Clyde at 9:00 a.m. I persuaded him to walk up
the ramp in front of my backdrop. His white hair glowed like a
crown as the early morning light behind him shone through. In
Maine I also attended the Union agricultural fair. I met an
electrician who had spent the past fifty years volunteering as a
magician at hospitals and community events (p. 31). He had his
own puppet, and he said making people laugh had given meaning
to his life. I also met men who raised champion birds, livestock,
and other animals. They posed gracefully with their prizewinners
in the bright August light.

Two weeks later I was in rural Montana attending a tractor

parade. The bleachers were filled with enthusiastic onlookers. There were displays of antique engines and grain threshers. I talked with a group of men from the local veterans home who explained to me how much farming has changed during their lifetime. I devoted the next day to learning about the Flathead Indians. There are over seven thousand living on their Montana reservation. Octave, a seventy-four-year-old, gave me a dancing lesson and explained the many symbols in his traditional dance regalia.

I tracked down celebrities who I felt would add another dimension to the book. I wanted to photograph older personalities from film, theater, music, business, and politics. Sir Ben Kingsley (pp. 108–109) told me he was feeling freer than he ever had and proudly showed me a henna tattoo, which he said connected him to his Indian roots. Frank McCourt (p. 96) came to a home-cooked Irish dinner with his wife, brother, and sister-in-law. After a glass of wine, I coaxed them to show me more of their pale white skin. We laughed together and I jumped behind the camera lens. We exchanged stories about growing up poor and Irish.

My assistants did Internet research to help me find men like Archbishop Demetrios (p. 47) and men from the Polar Bear Club. I visited Voodoo Priest Clotaire Bazile on Good Friday (p. 107). He told me he couldn't fix a broken heart but could help with infertility and many diseases. His altar, statues, and plates of rocks and eggs filled a whole room.

Lastly, late one night as I was getting ready for bed, one of my subjects knocked on my door with a present for me. It was box of letters his deceased wife had left him. They were all neatly tied up with string like a ritual offering. He said he thought I would be the type to appreciate the letters long after he was gone.

I feel grateful for all this book has given me. I always photograph with the hope that I will be graced with moments of personal discovery. I have tried to translate these experiences into photographs that are collaborations and that show the complexity, depth, and uniqueness of all my amazing subjects.

JOYCE TENNESON
New York, 2003

You have to do what you love doing, otherwise you will get ill. I've been teaching for thirty-four years. I love it. It's a way of life. It takes patience, knowledge of your craft, and a sincere desire to help others in their own growth and development.

—Gene Arant, 74,
and grandchildren

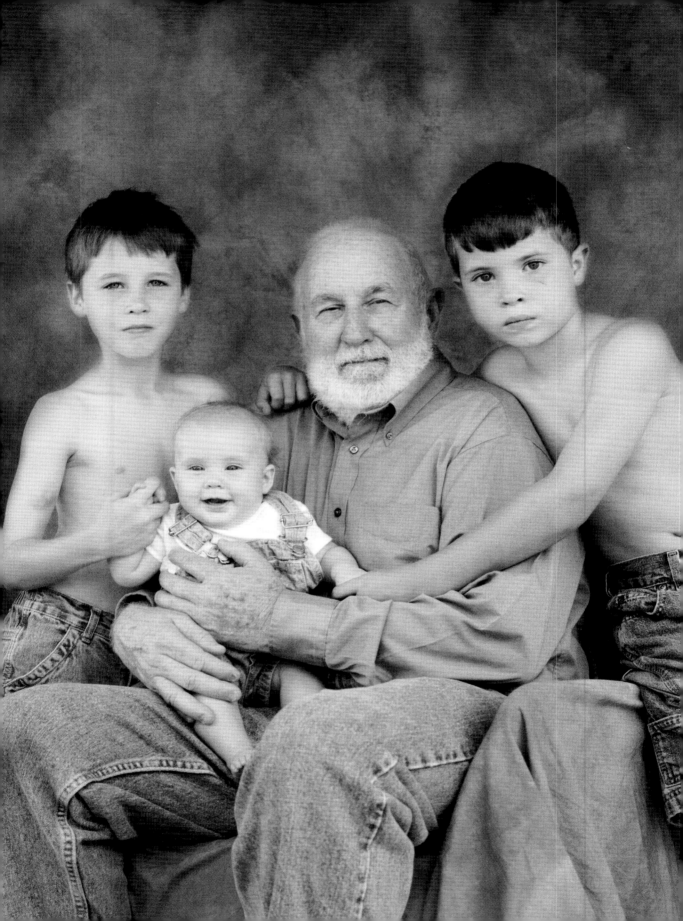

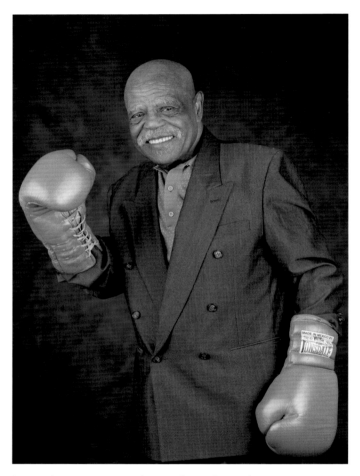

I am the great-grandson of a white slave owner
from North Carolina. I have relatives that fought
on both sides of the Civil War. I was in World
War II. Since then, I have worked with sixteen
boxers who later became world champions. I never
dreamed I'd coach a gold-medal winner like
George Foreman. My life purpose now is working
with the young and helping them turn out right.

—Doc, 83

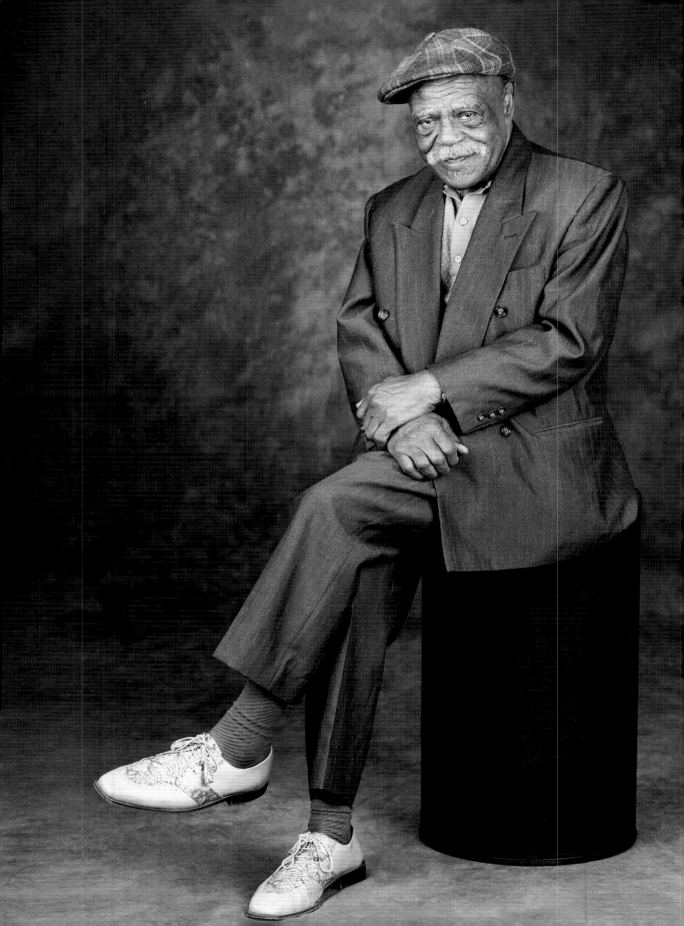

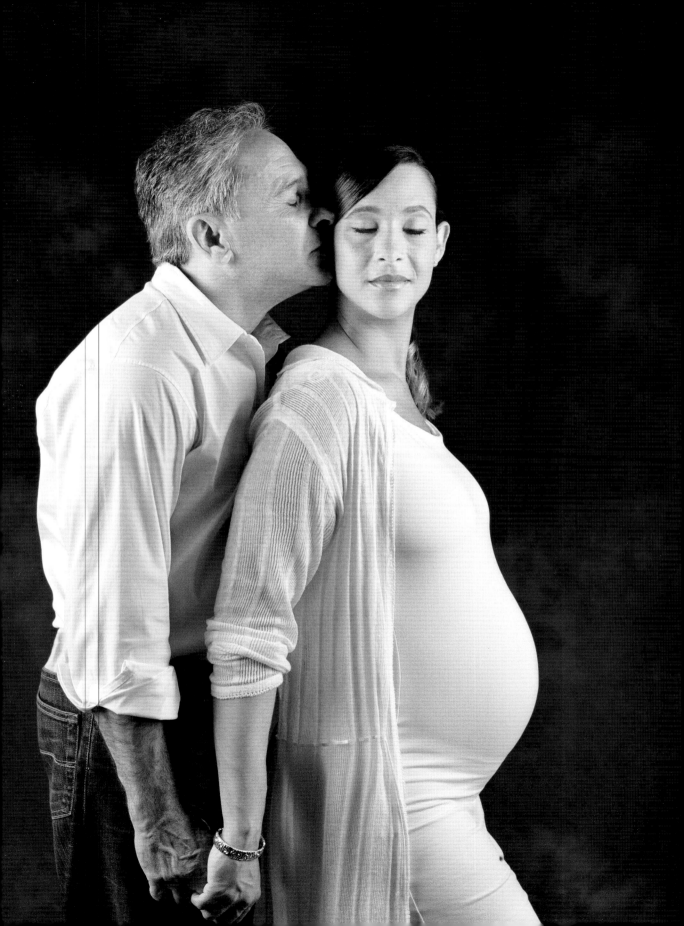

Having a baby at this point in my life is a miracle.
Adventure is always worthwhile. Our new baby will bring
us a new world.

—Renaud Doura, 60,
and wife

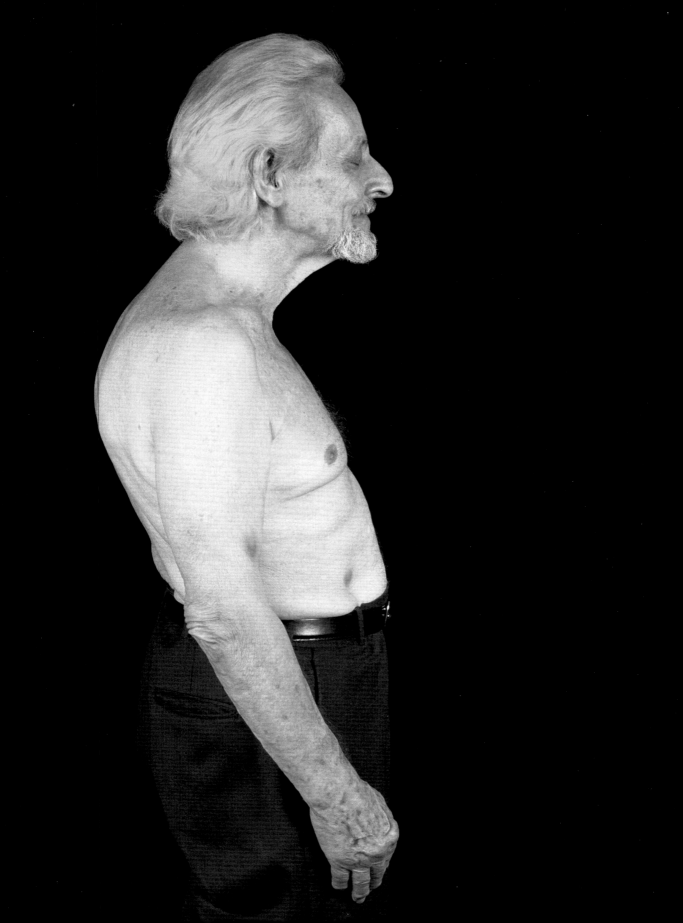

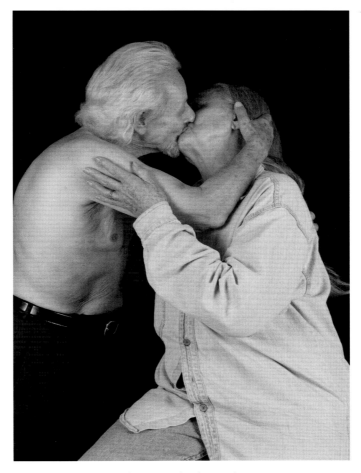

As an artist, one has to "feel" and to journey through life. My work is suffused with love for this planet, and I am still passionate about my wife after half a century. Let me also add that this is my eighty-first season of skiing!

—Paul Jordan, 86,
and wife

There are so many things I have left to do in my life, but I never tire of being called the King of the Blues.

—B.B. King, 76

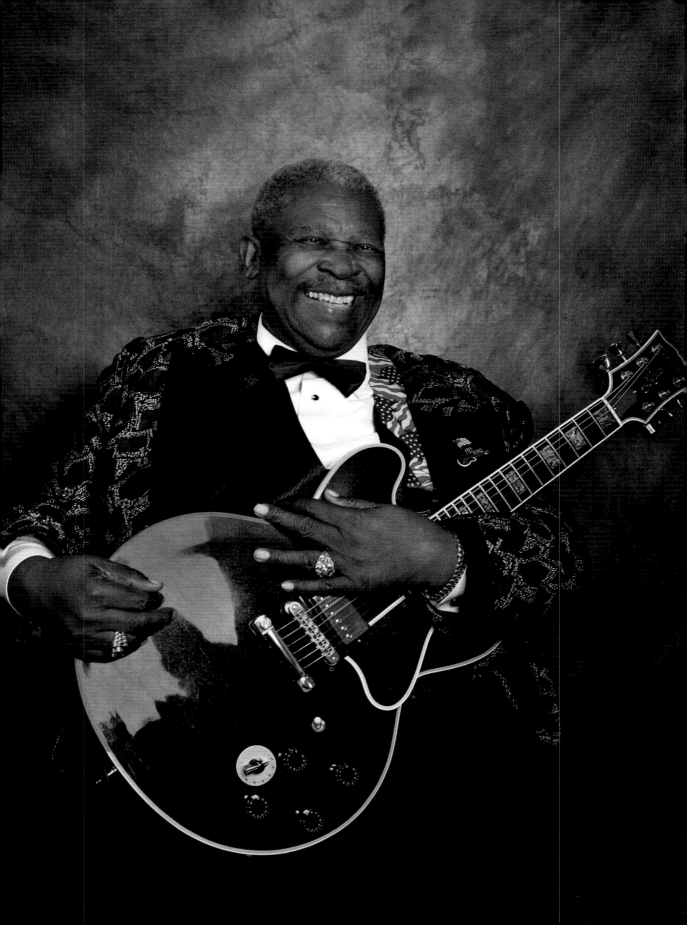

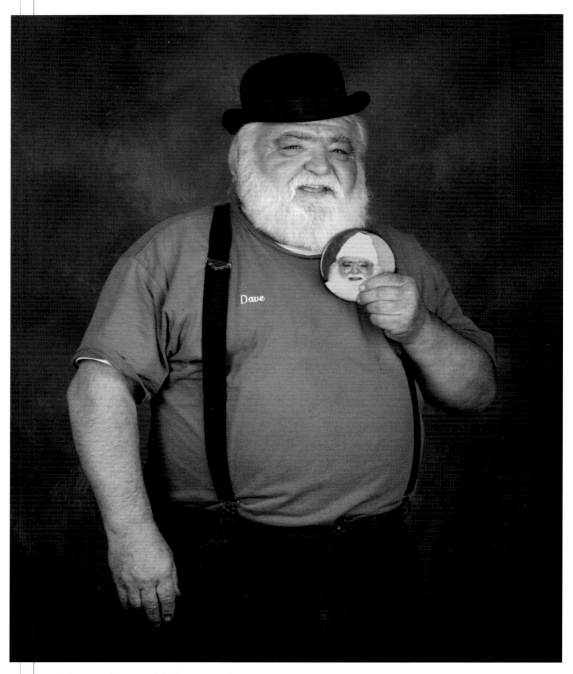

I started being Santa Claus over thirty years ago. Whenever you represent
that gentleman, you have to be friendly and courteous. I cut my hair recently,
hoping people wouldn't recognize me, but kids still come up and call me Santa, so I
wave and smile back.

—David Montmeny, 66

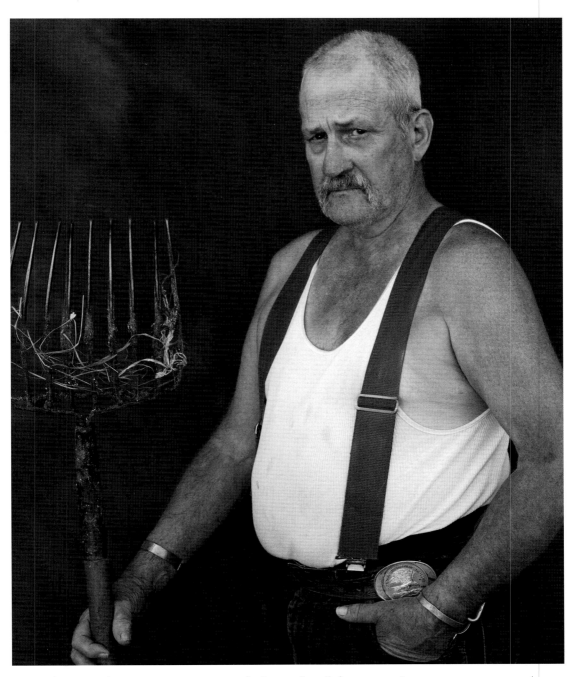

I was born in the same room as my father. Small farms can't survive anymore; they are swallowed up by the bigger ones. I miss having cattle to tend to. My sons have moved off the farm.

—Irwin Pillsbury, 66

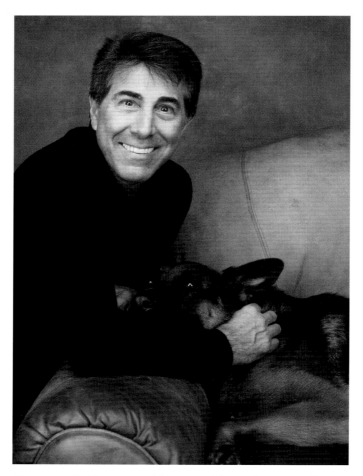

Creating Bellagio and being able to bring real art
like van Gogh's to Las Vegas was thrilling. The
fact that my sight is impaired does not hinder me
from identifying a masterpiece.

—Steve Wynn, 60

I love being called the Candy Man. I travel to fairs and meet children from all over. The back of my shirt says, "The Candy Man Can." That sums it all up.

—Ray Lee, 77

Poet Laureate is a hard thing to call yourself because it's
so honorific. Who would have thought staying up at night
pushing little words around would lead to such adventures?
The muse for poetry is jealousy or envy. Otherwise you
are just spinning your wheels.

—Billy Collins, 63

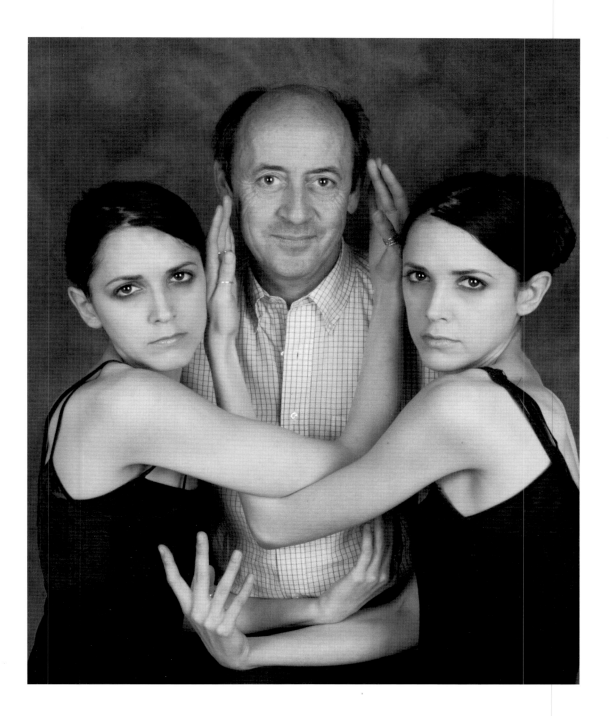

Alpaca is the fastest-growing livestock industry in America. A "proven" male can cost between twenty and forty thousand dollars. One sold last year for $250,000. The females go for under twenty.

—Floyd Malcolm, 72

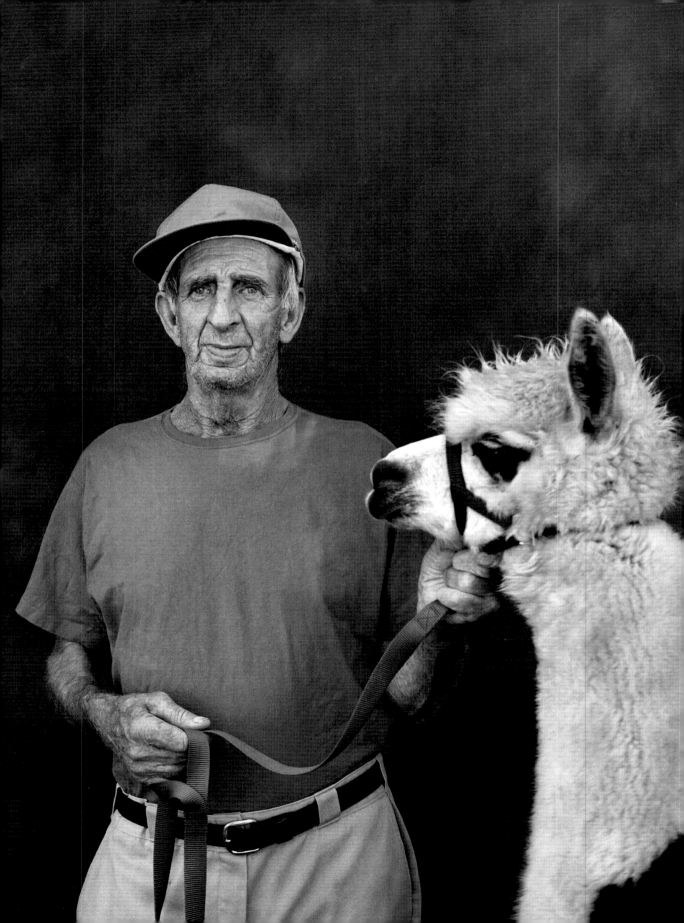

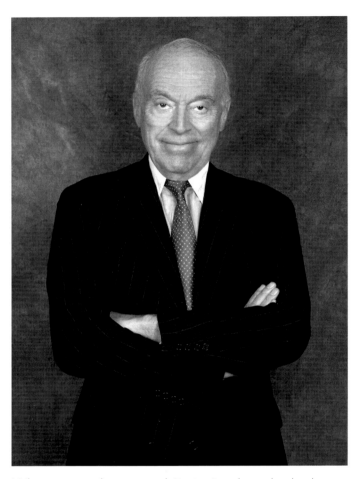

When my mother started Estée Lauder, she had no idea it would turn into a $5-billion per year business. If you have a great idea, keep a low profile. Learn from David and Goliath: start with small weapons to beat the big guys. Start small and go after a market with a focused target.

—Leonard Lauder, 70

I think we all go
through that strange
time in our lives when
we think, "I better find
out who I am." It's
important to know that
before you perish
completely.

—Gay Talese, 70

I've been a magician for fifty years. People like to laugh, but they are afraid to nowadays. This is my favorite puppet. He teases me. As a Taurus, I need that dimension in life. Together we can get people of all ages to open up and laugh. That gives my life meaning.

—Fred Goldrup, 69

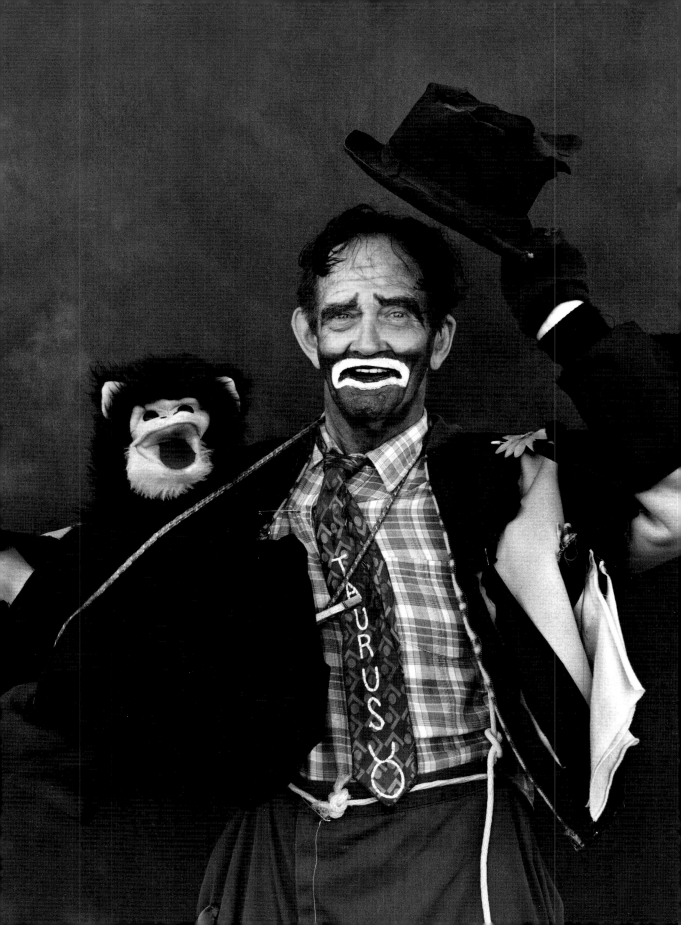

Art is not what you see, but
what you make others see.

—Jasper Johns, 73

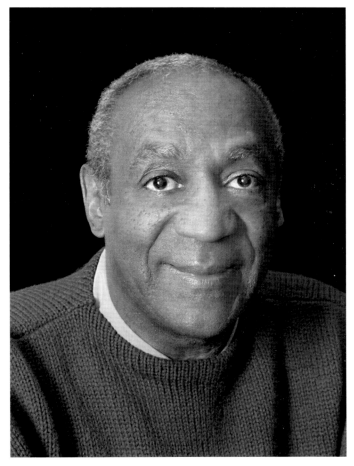

Nothing separates the generations more than
music. By the time a child is eight or nine, he has
developed a passion for his own music that is even
stronger than his passions for procrastination and
weird clothes.

—Bill Cosby, 66

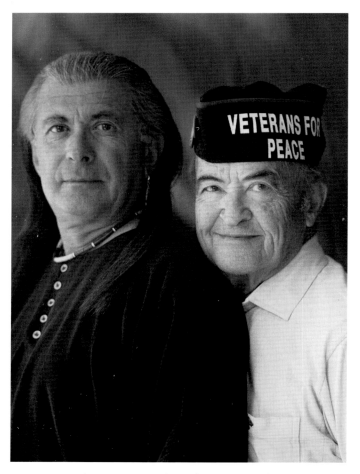

Our group has no nostalgia for war. Life is an unending struggle to get peaceful resolutions of local and international conflicts.

—Norm Budow, 78

We live in a great country. I have learned we must take responsibility for ourselves and have respect for others.

—Daniel Valdez, 60

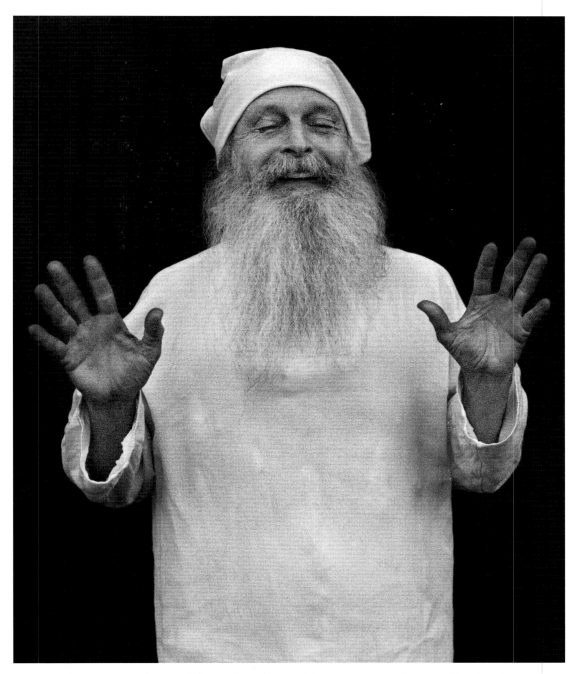

As a sculptor, I've always felt my hands are like wings, my fingers like feathers. It's the way I can best fly.

—Arnand Naren, 62

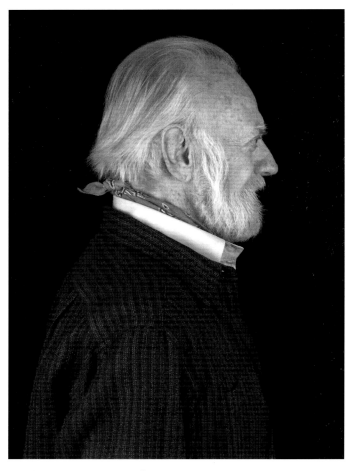

God, I miss Al Hirshfeld. I never knew I could miss someone so much. He was so affirmative. He didn't know how to lie, and that was why he was so nourishing to us all.

—Paul Jenkins, 80

My autobiography is in my drawings. I've never lost interest in line. Some people call my work caricature, but there is no anatomic distortion in my work — it's really portraiture.

—Al Hirshfeld, 99

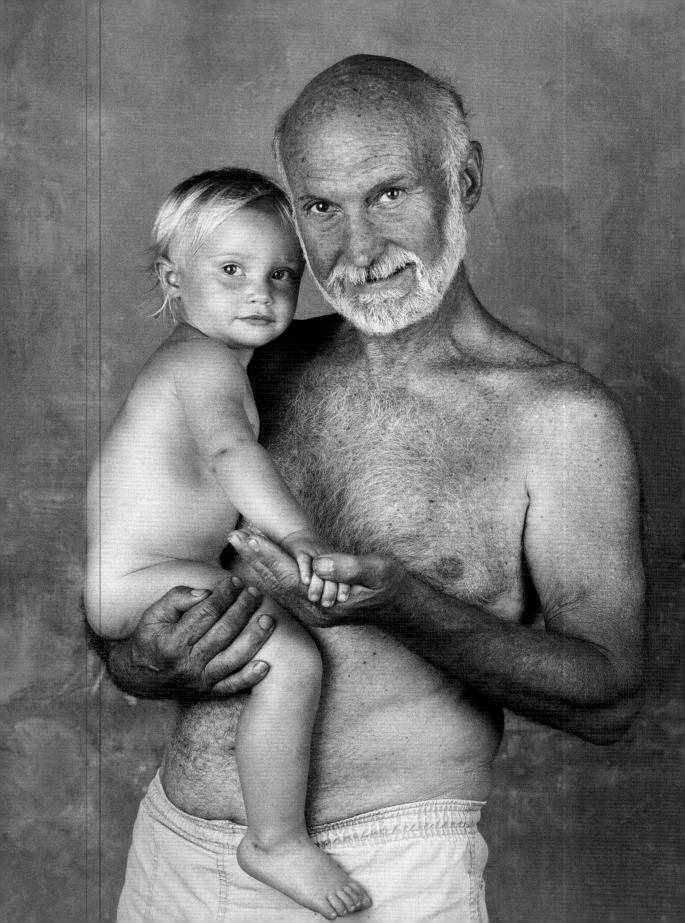

My son Havanna was conceived on a trip to Cuba. It's hard for me to understand how I buried myself in my business all those years. Being a dad is definitely my greatest life joy now.

—David Lyman, 65, and son

We play dominoes together every day from 8:00 a.m. to 3:00 p.m. We used to load sugar cane. We still think the Cuban girls are the sweetest. Dominoes and girls are our passion.

—Ricardo Gonzales, 81,
and Bienvenido Palacio, 65

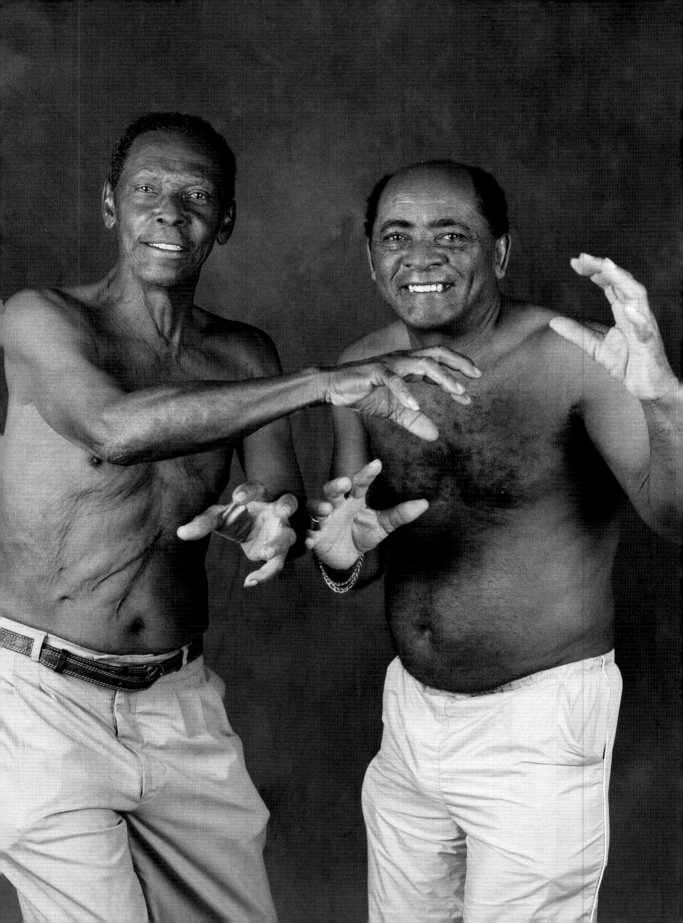

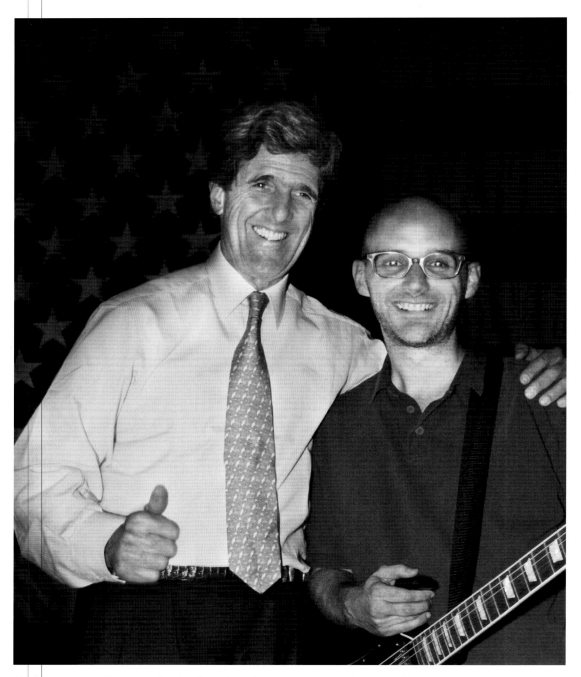

I've been willing to fight for the things that make a difference in the quality of life in America.

—Senator John Kerry, 60, and supporter Moby

My parents always told me to respect children. I've been a scoutmaster for 45 years. We serve youth. Our motto is duty, honor, and country. I was born in Puerto Rico. I came to the U.S. with my father when I was fourteen. We couldn't afford the scout uniform at that time. Scouts can help you realize the American dream.

—Joseph Santiago, 70, and cub scouts

David and I have been close friends for thirty-six years. There's no substitute for history. A good director helps you realize you have nothing to prove. My work in the theater now is more fun, more stimulating, and sexier than it has ever been in my life!

—Patrick Stewart, 63, and David Jones, 65

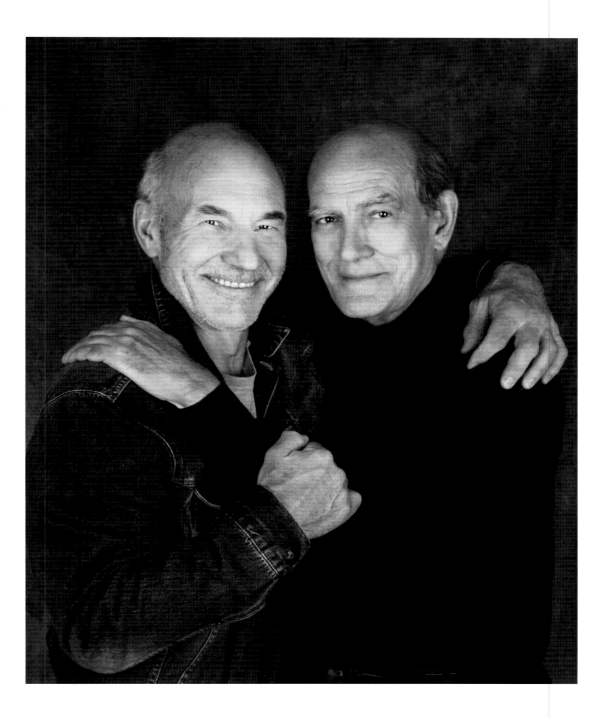

As an archbishop, I hold this staff as a symbolic reminder of my mission to protect my flock. My goal in life is to be a vehicle for something higher, to be a guide for compassion and courage.

—Archbishop Demetrios, 75

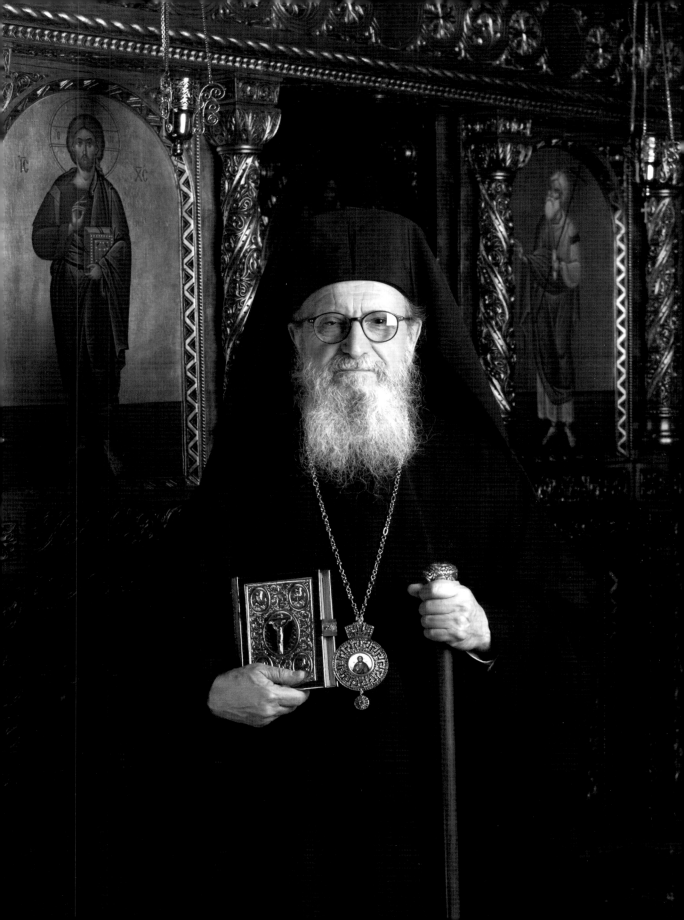

I was twelve when my father, who created the *Babar*
books, died. I wanted my friend, Babar, to continue living.
Since then I have published thirty books of my own.
Babar's Yoga for Elephants was inspired by my own twenty-
five years of practicing yoga.

—Laurent de Brunhoff, 75

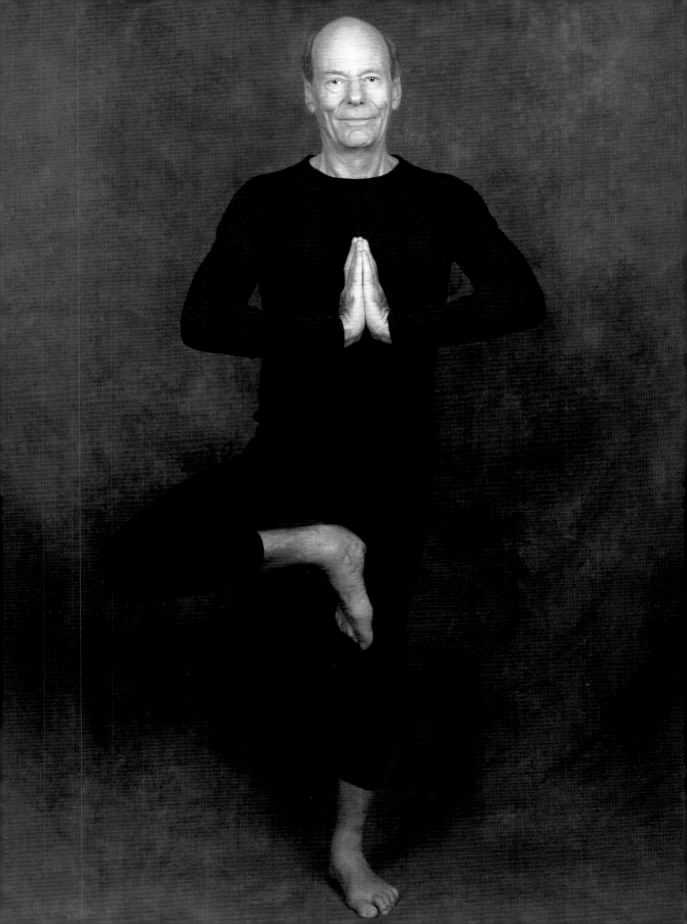

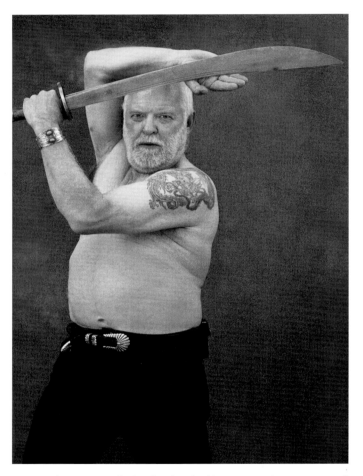

Martial arts combine both challenge and a sense of fulfillment. It is not about violence, it is actually about peace. I taught kids in New Mexico who wanted to fight. The discipline of martial arts helped them to realize that through their minds, they can arrive at a harmony with the world, and this eliminates the need to fight.

—Douglas Kent Hall, 65

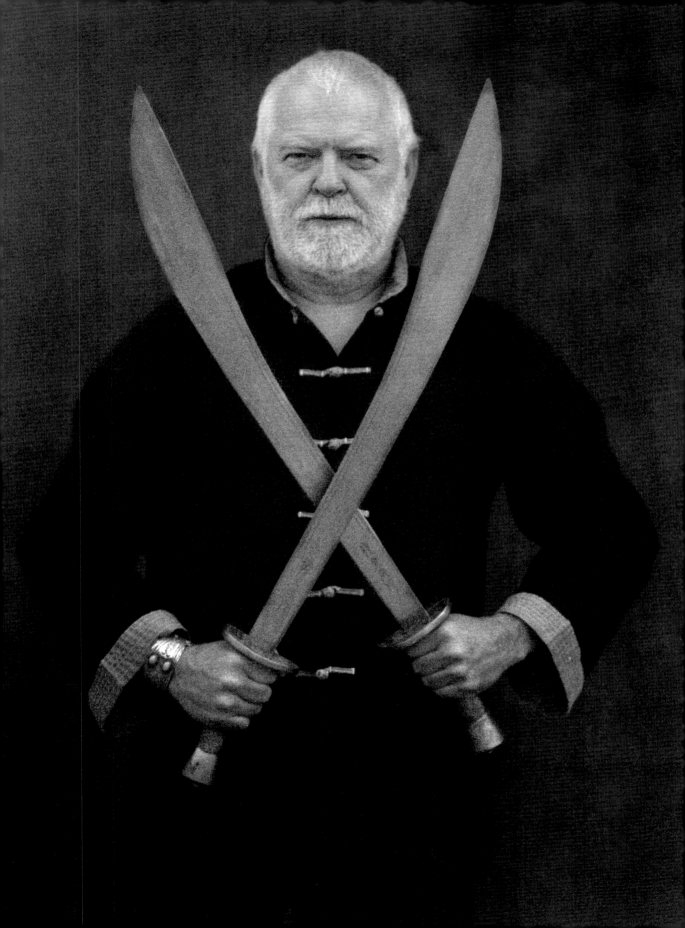

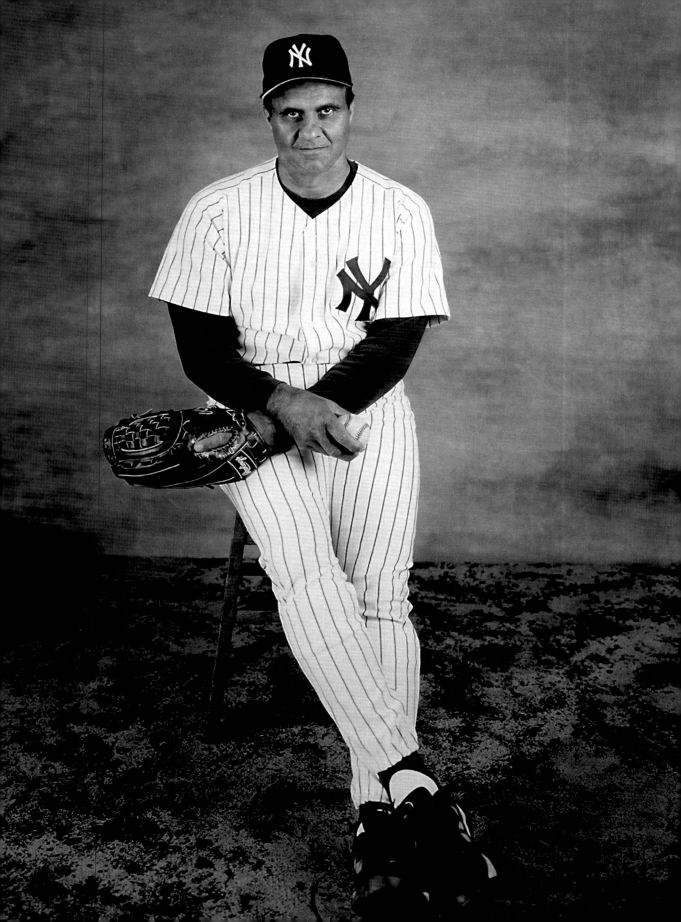

When we lose I can't sleep at night. When we win, I can't sleep at night. But when you win you woke up feeling better.

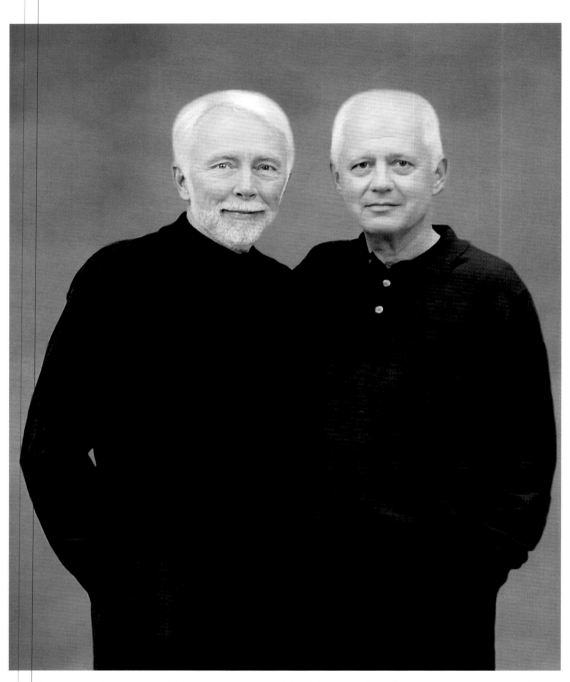

People depend on us to help create a world of beauty for them. We act as guides in the process of decorating. We've been together twenty-six years and still enjoy the hunt to find the perfect objects for our clients.

—Bill McGee, 66,
and partner

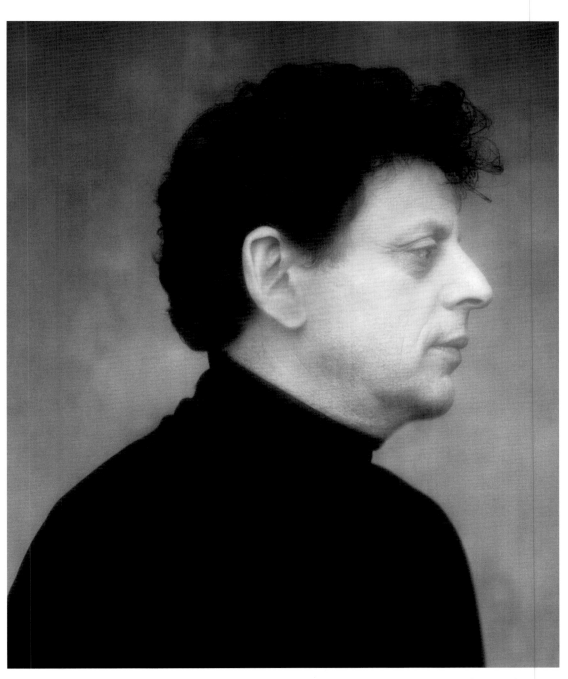

Years ago, I found out there were a lot of things I wasn't supposed to do, and I said, "To hell with that!"

—Philip Glass, 65

I never thought I'd live this long. Clean living and dirty thoughts probably did it. I don't believe in adhering to any rules I don't support and I didn't vote for. To hell with what people think. Just be who you are and you'll be happy.

—Willie Nelson, 70

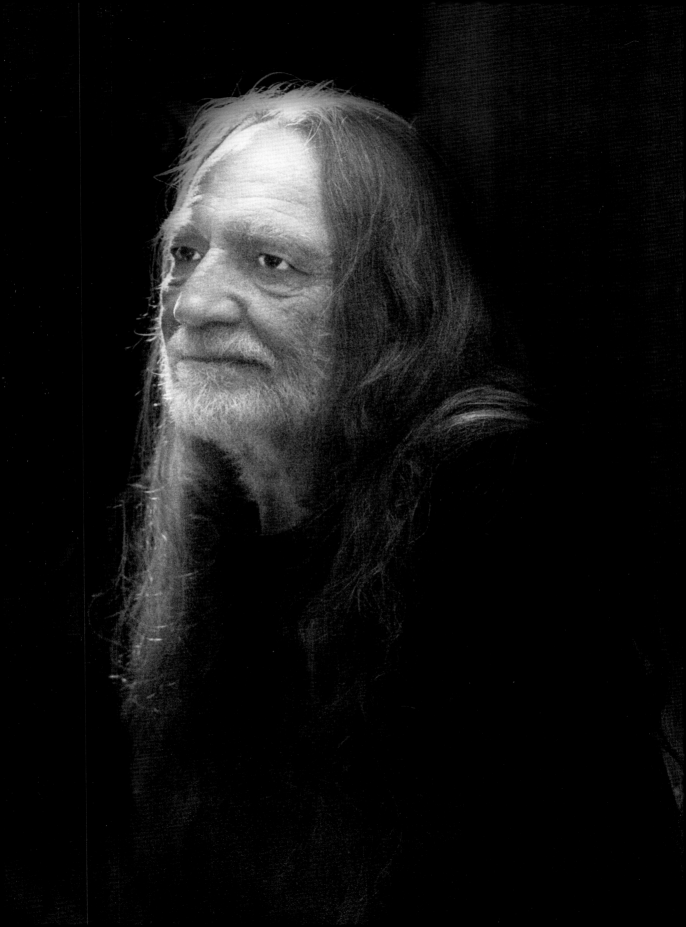

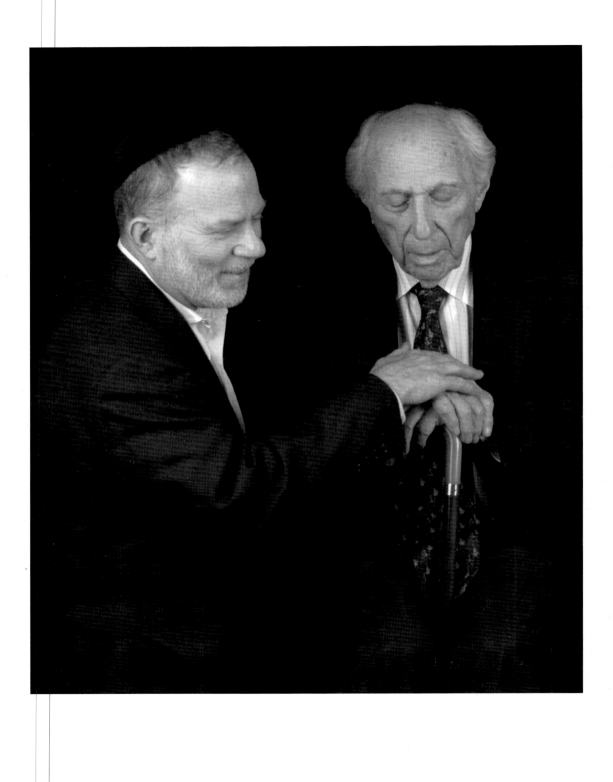

Helping artists and developing museums is an old tradition in the financial world. Wall Street enabled me to buy more than a thousand works of art and to become an art advocate and activist. At age one hundred, my appreciative senses remain sharp.

—Roy Neuberger, 100,
and son

In life, one must make a choice and accept the consequences.

—Arthur Schlesinger Jr., 85

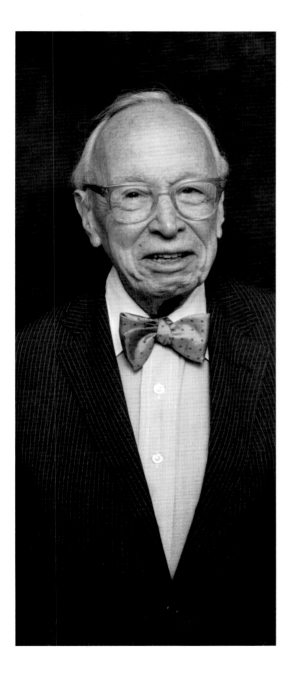
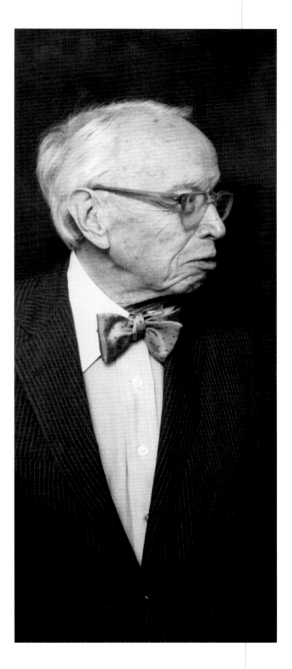

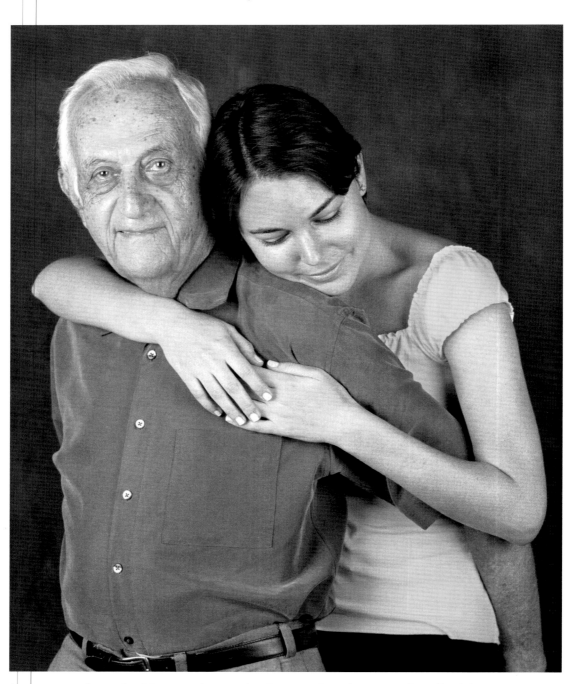

I ran away from the Ukraine during the Russian Revolution and walked for a year and a half in hiding until I got to Poland. I was eight. Then I took a boat to Argentina, which was the only country to accept me. Now I live with my granddaughter Mariela. I still write my novels in Spanish.

—Simon Rensin, 88,
and granddaughter

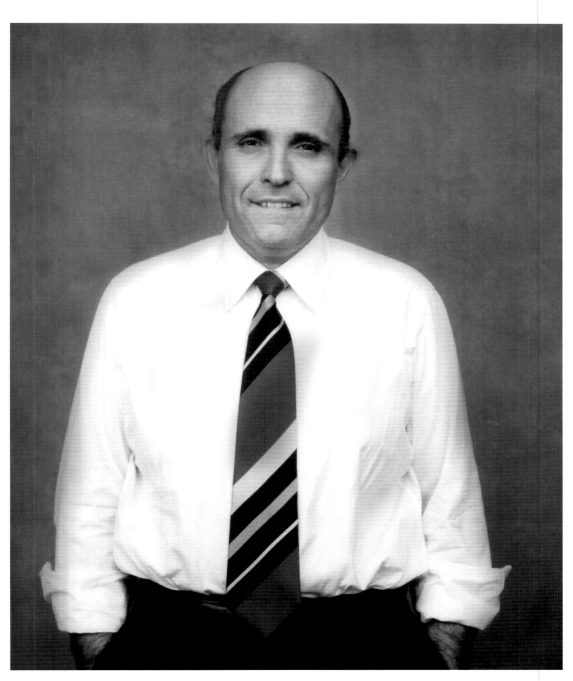

Look, in a crisis you have to be optimistic. There are parts of you that say, "Maybe we're not going to get through this." You don't listen to them.

—Rudolph Giuliani, 60

Being a fireman is the best part of my life. These men are my brothers and they will be my brothers 'til they are no more. I still get very upset when any brother passes away.

—John Fazio, 66

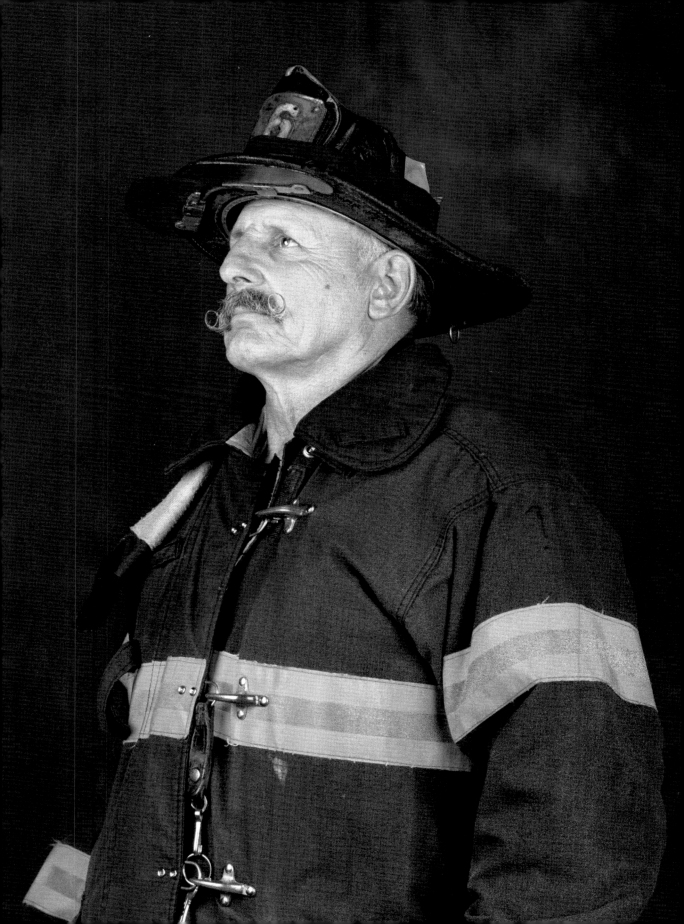

After forty years as head of an art school, I now have time to spend with young students—not as an administrator, but as a mentor and a friend. I admire young people who have a sense of style, even if very different from my own.

—Joseph Canzani, 87,
and mentee

I arrived in America in 1962. Egypt
didn't like Catholics then; they
called us "the pope's boys." I had
a law degree but couldn't speak a
word of English. I washed dishes
for nine months and the owner
called me "boy." Over the years,
I built my own successful business.
I believe when you're smart you see
opportunity. If not, shame on you.

—Joe Abdemour, 72

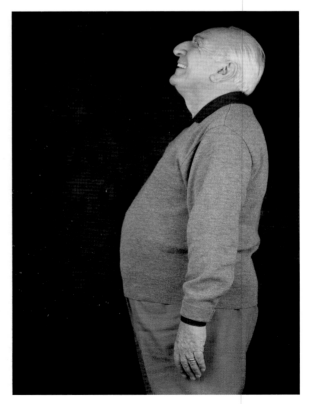

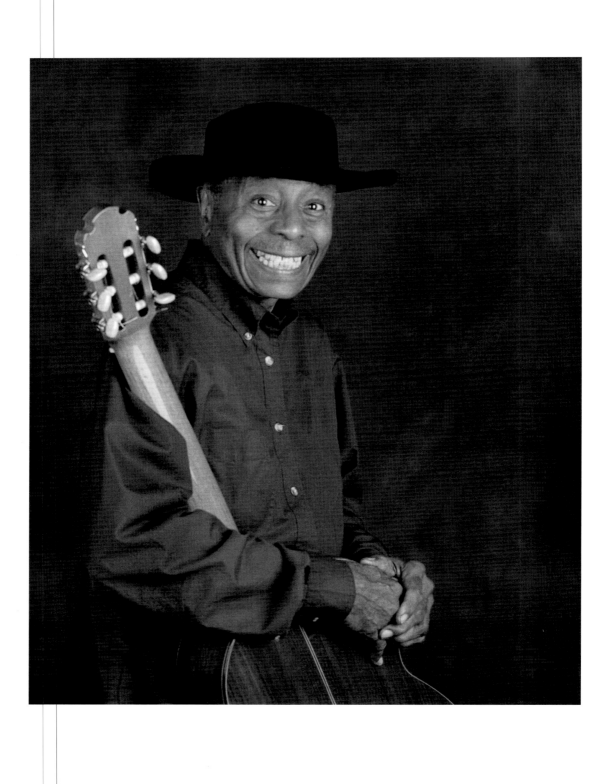

I sing and play as easily as I breathe. I don't have to worry about having perfect English when I perform.

—Alberto Menendez, 76

Journalism is so much about documenting the failures of human nature. Yet after forty years in this business, I have an abiding faith in the resilience of mankind and the determination of more people to do good than evil.

—Tom Brokaw, 63

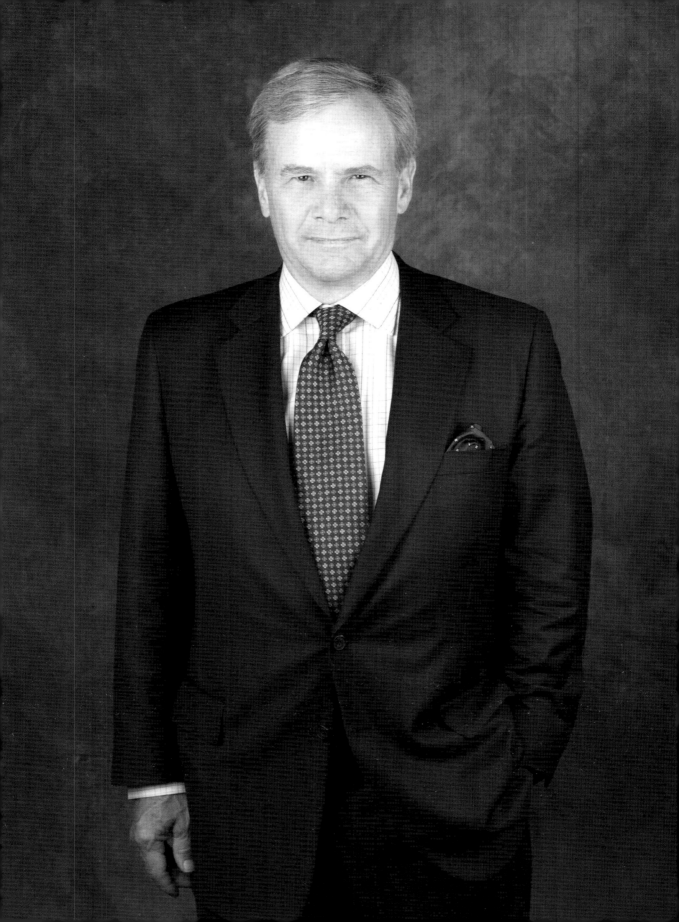

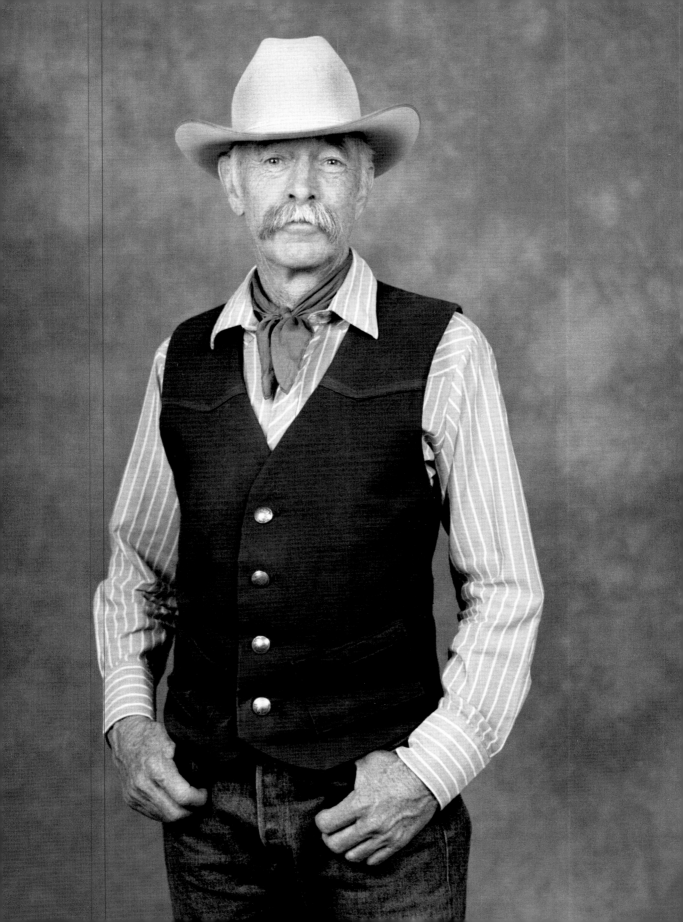

When I was in the military, I saved my money so I could buy a cattle ranch. It's been my life ever since. Being a cowboy is more of a romantic concept now; small cow farms don't make economic sense anymore.

—Archie West, 65

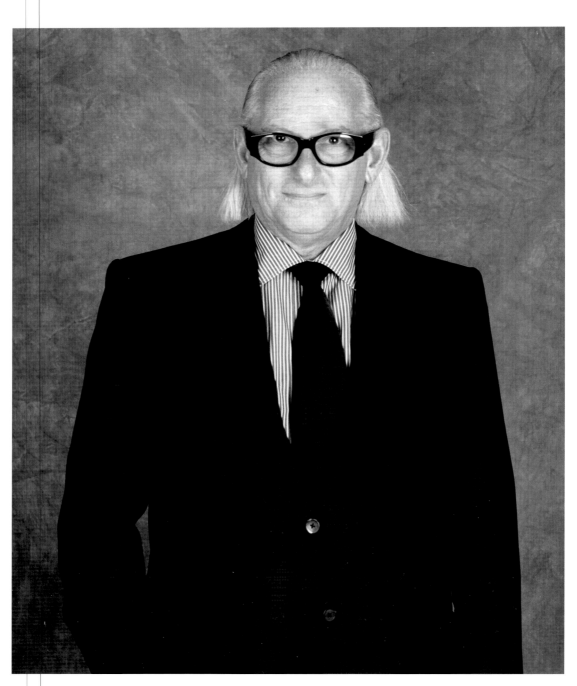

As the president of Express, I'm paid for my ability to see trends. I have to be careful about how I dress. You don't want to look silly; people in our business get caught up in fashion trends and look ridiculous.

—Michael Weiss, 62

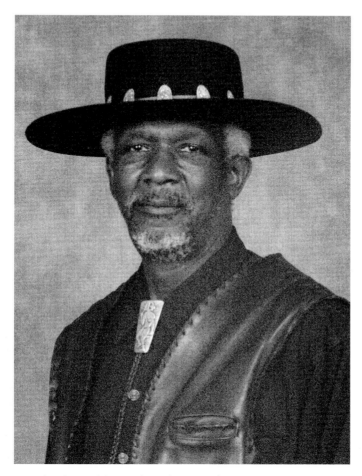

I've had trouble with color, so forty years ago my wife suggested I wear black. I've done so ever since. Time passes quickly; men often don't realize what's really important in life 'til they are in their sixties.

—Lewis Calbreth, 65

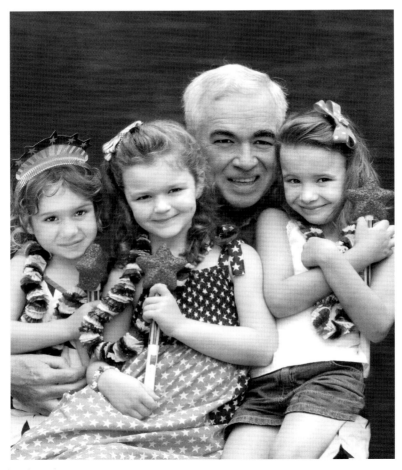

Seeing the world through my three granddaughters' eyes is special. The Fourth of July is always a great family day. The girls sing "It's a Grand Old Flag." It's a yearly tradition we all cherish.

—Jack Doyle, 60,
and grandchildren

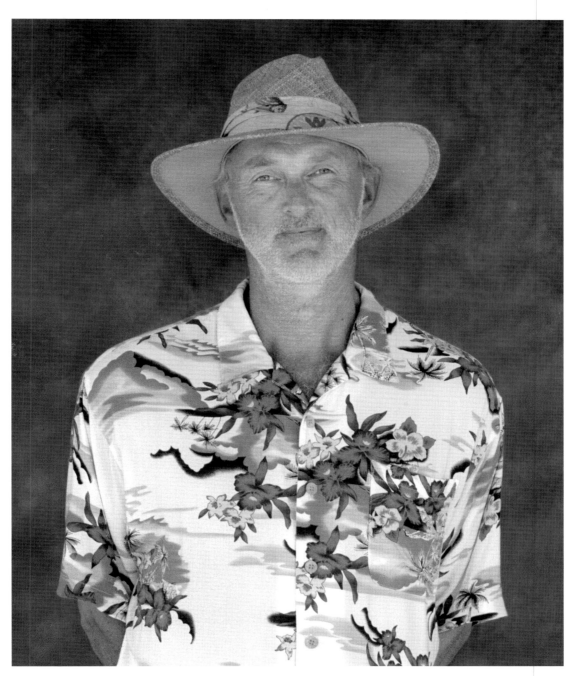

I just retired. I've been coming to Florida to visit friends for thirty years. They passed away and left me their home – they knew how much I loved it here. My life is beginning a new and wonderful chapter.

—Tom Weir, 63

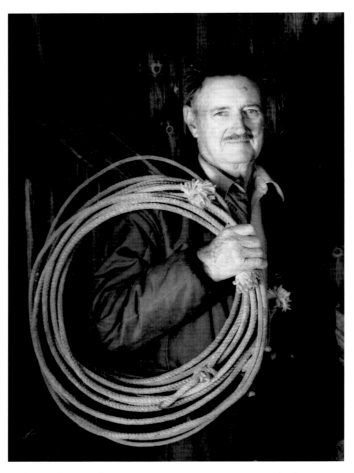

What I love about Montana is its uncrowdedness.
Nature makes my ranch an almost magical and
holy place. My wife passed away last year. I still
can't get over it. I still feel married.

—John Stollfuss, 82

I've been dancing since I was eight years old. It makes me feel good inside. We dance for others who can't, those who are sick or old. Dancing in a circle shows unity. We share our strength in that way. The eagle feathers help put us in touch with the energy of strength and spirituality.

—Jimmy (Rock Boy) Malatare, 60, and friend

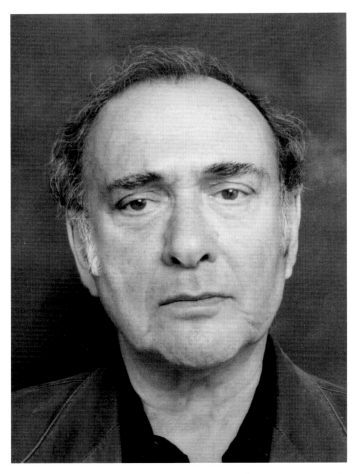

Sometimes, in poems, I am only dimly conscious of the grounds of my activity, and the work proceeds to its own law and with me as a go-between, as it were.

—Harold Pinter, 72

My book *The American Century*, written after a two-year journey through the United States, gives a view of twentieth-century America through my eyes as a foreigner. I realized that America's strength and prosperity were due in large part to the expansiveness of American freedom, which lies at the heart of this country, a freedom that necessitates responsibility.

—Harold Evans, 75

Our club of sixty is called the Silver Fox Dancers. We do country line, jive, cha-cha, rhumba, and perform at local events and festivals. I get a real buzz from dancing.

—Joe Arsenault, 67, and dancer

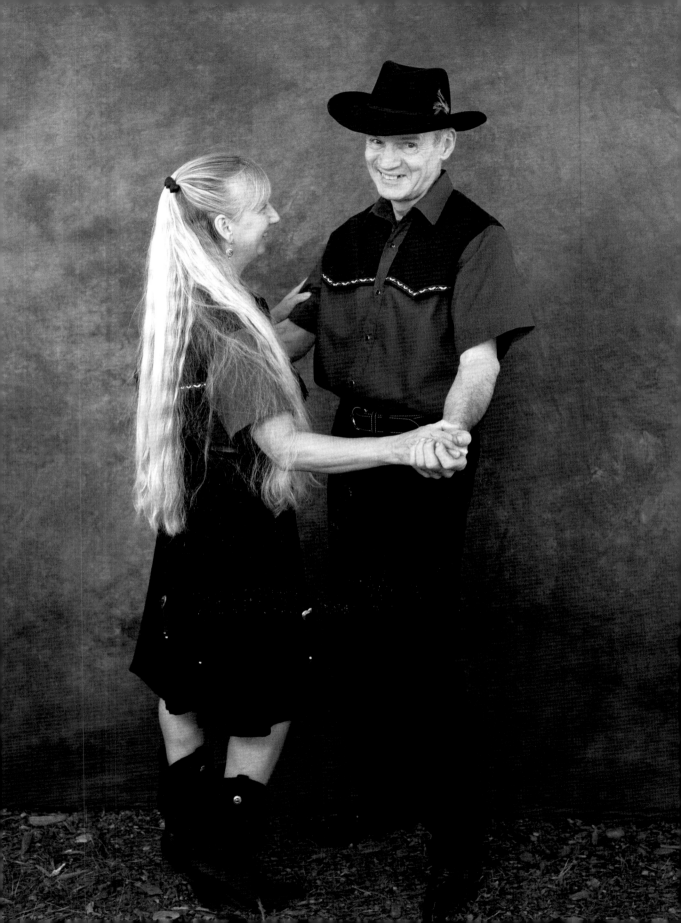

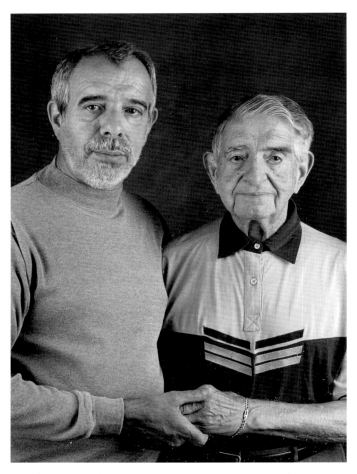

My father and I have the same name. He has Alzheimer's disease now. My love and sense of protection for him increase daily.

<div align="right">

—Thomas Gonzalez, 83,
and Tom Gonzalez

</div>

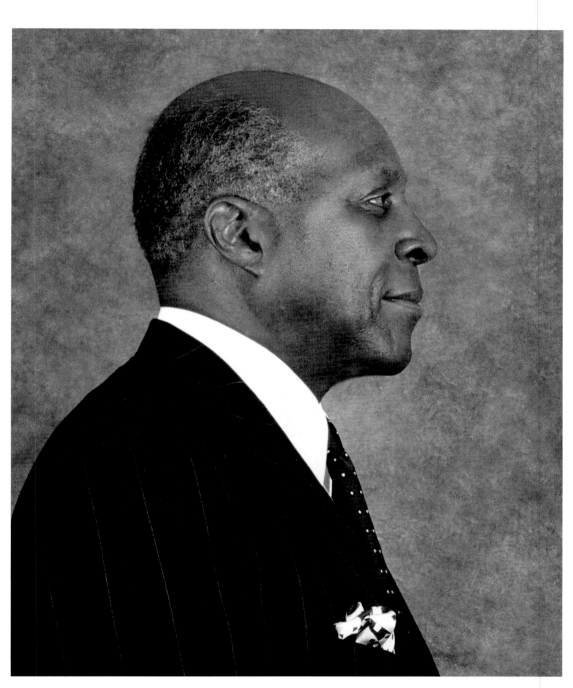

To do justice, love, mercy, and walk humbly. That is what I've learned from life.

—Vernon Jordan, 68

I was born without a right forearm. My parents
never treated me like I was different. After getting
a doctorate I started a theater group for the
handicapped. We celebrate disability and the
growth that comes with acceptance.

— Brother Rick Curry, S.J., 62

I had my son, Aaron, in my fifties. At eleven months old he was already memorizing whole scores of music. Although he's an amazing musician, his real love is comparative mythology. He has a global awareness of the intrinsic nature of human beings. I'm proud that at his young age he feels confident enough about himself to pursue his true passions.

—Lorin Hollander, 60, and son

I was a male nurse for thirty-eight years. There were few
men in the field back then. I'm worried now that people
who really need health care aren't getting it because they
can't afford the insurance. I never felt I had to fit into any
category. My work showed me that when there is care and
love, there are always miracles.

—Amos Chiarappa, 87

If only I had a little humility, I'd be perfect!

—Ted Turner, 61

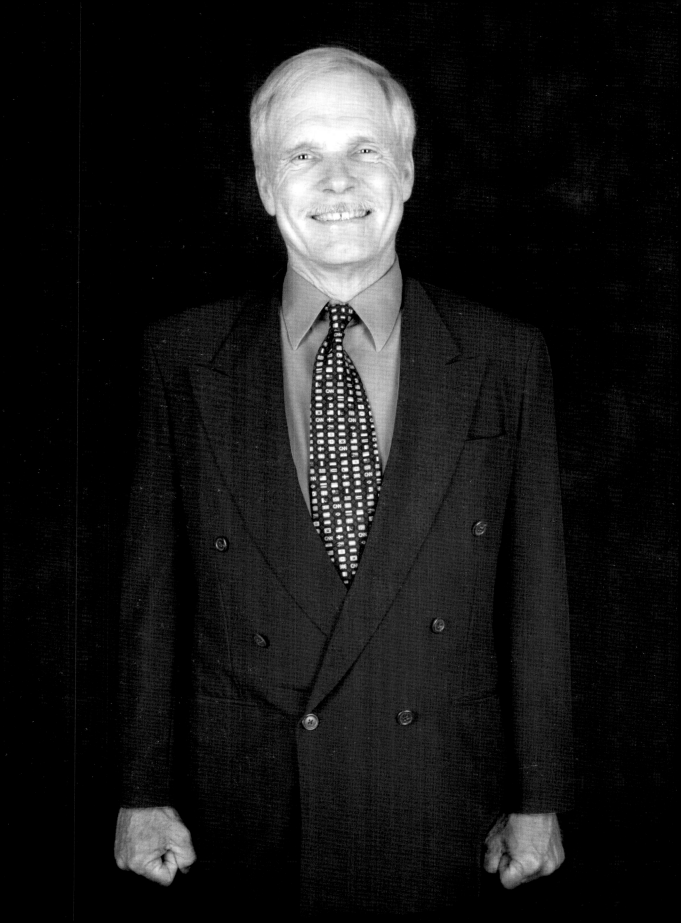

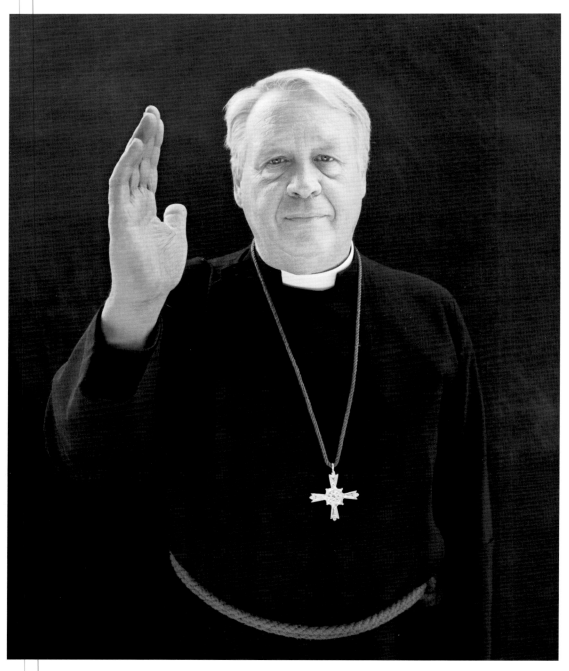

God has given each of us a unique gift that must be discovered, nourished, and passionately used.

—Archdeacon Michael S. Kendall

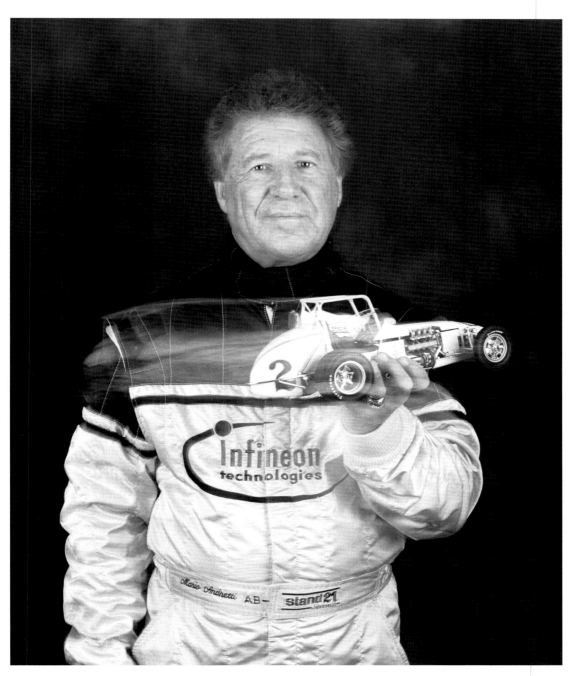

If everything is under control, you are going too slow.

—Mario Andretti, 63

My daughter didn't experience me directly as the Chief
Commander of the Armed Forces of Haiti. However, she
still teases me about how I used to get her up at five every
morning during her school vacations to exercise. I know a
disciplined life brings success.

—Lt. General Herard Abraham Fadih, 63,
and daughter

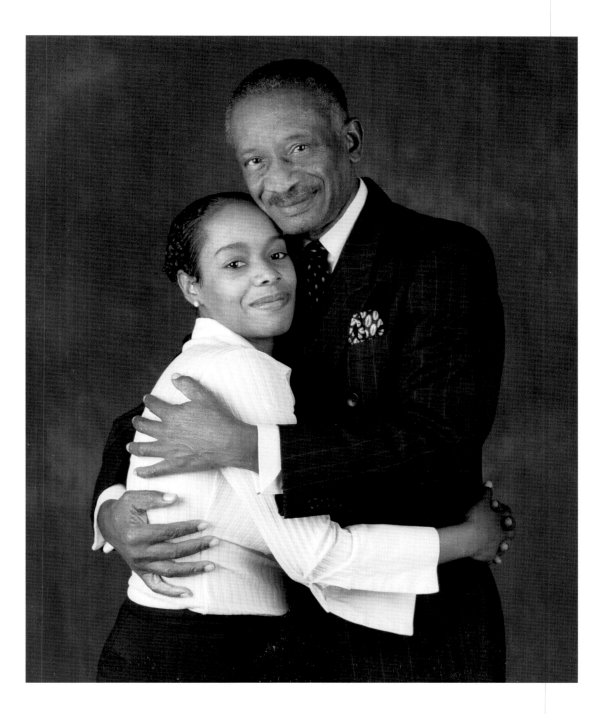

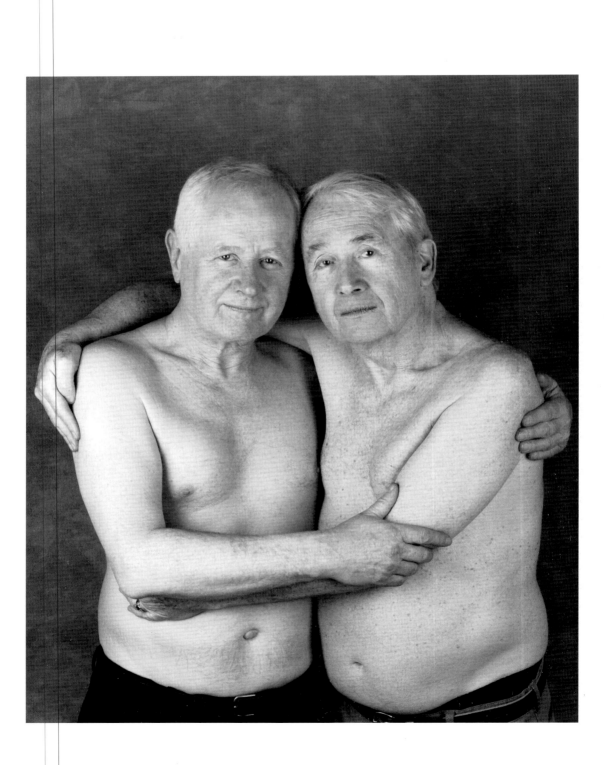

When I look back on my childhood I wonder how I managed to survive at all. My brother Alphie and I slept in the same bed together when we were young. We've had different paths in life, but are still connected as deeply as we were when we were young.

—Frank McCourt, 72,
and Alphie McCourt, 62

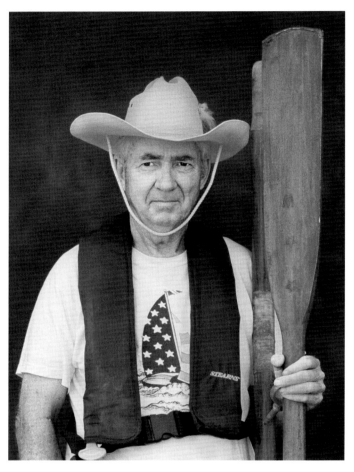

It took me a year to build my own boat. It's one of
a kind. Sailing is exciting. When the wind takes
over, I feel young and free.

—Ken Westcott, 63

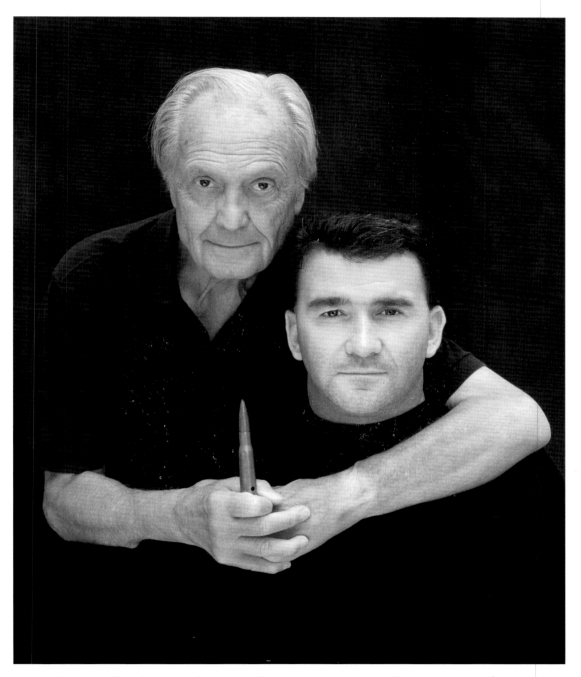

I was shot in a bombing raid on March 18, 1944. I was the navigator of my group of ten men. While I was in the hospital, our plane blew up over Germany and all nine others were killed. Since then, helping young people before they get into trouble has been my mission. I met Casey when he was eleven. I'm proud of his success in business and his strong character. We have become family.

—Ken Carlson, 83, and mentee

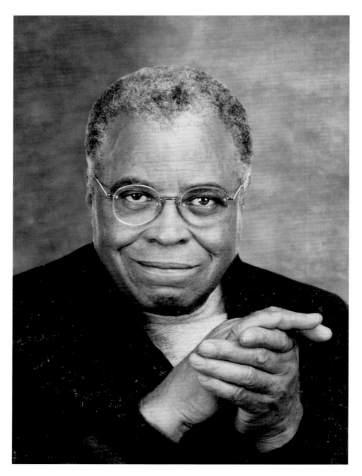

When you believe in a character, you sometimes cry for that character. Sometimes it's not appropriate. You have to hold back. To have that sort of strength, to summon that energy, is what I want to do in my life and in my craft.

—James Earl Jones, 71

I never married and had my own family. I had eight brothers and sisters to support and put through school. They're all doing great now. That was my mission.

—Khing Oei, 75

I photographed ten United States presidents, and many other celebrities, but in the end, the most important thing in life is family and friends. Everything else is just wallpaper. My wife, Gus, and I still hold hands every night when we watch the news.

<div align="right">

—Arnold Newman, 85,
and wife

</div>

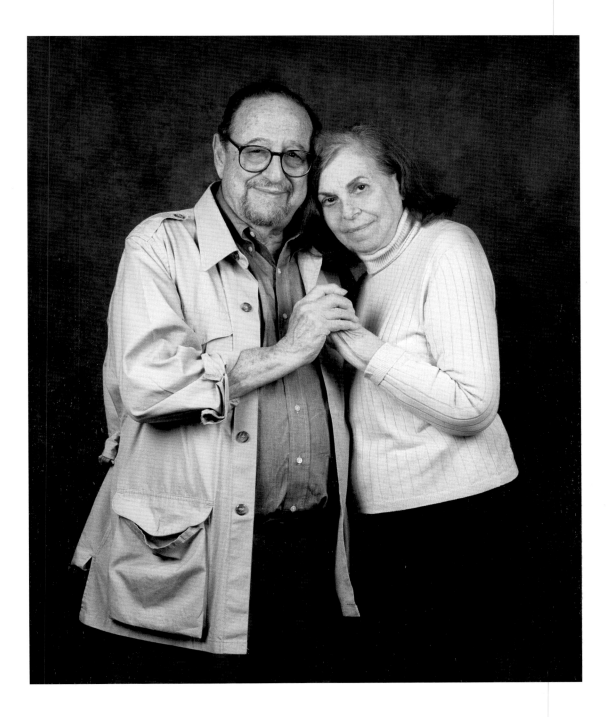

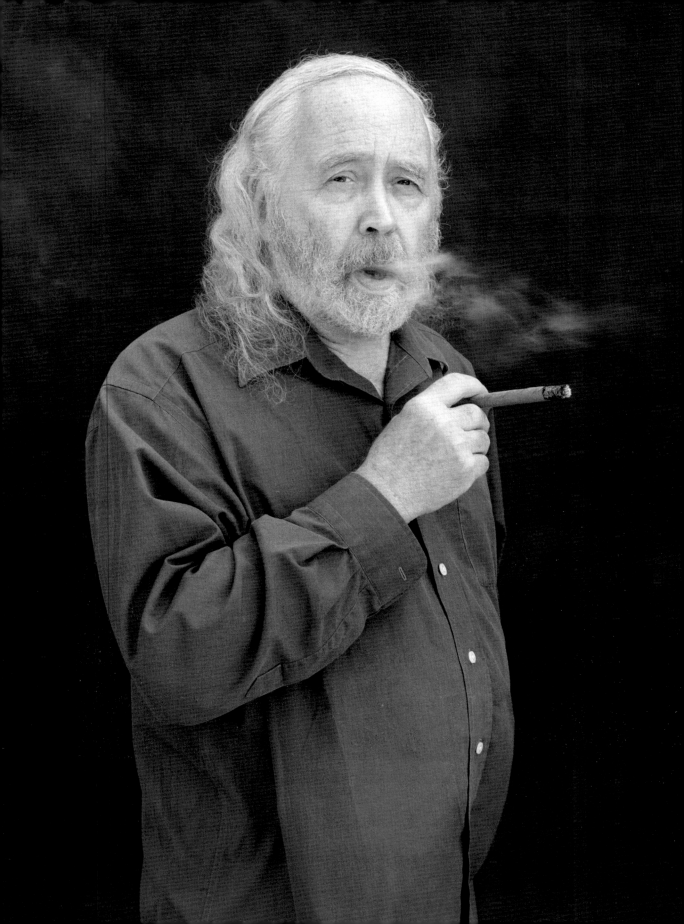

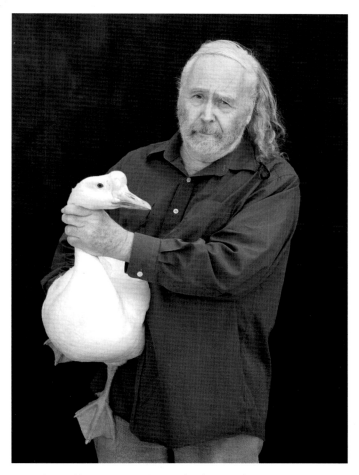

People still connect me with the sculpture *Love*,
which I created in 1966. Pop Art has maintained
its large audience through its interest in popular
culture. I have plastic geese in my windows, and a
flock of live geese in my backyard.

—Robert Indiana, 75

The spirits chose me when I was seven years old. I've been a voodoo priest for over fifty years now. This is our Black Madonna Freda. I can't cure a broken heart, but I can heal many other diseases.

—Clotaire Bazile, 70

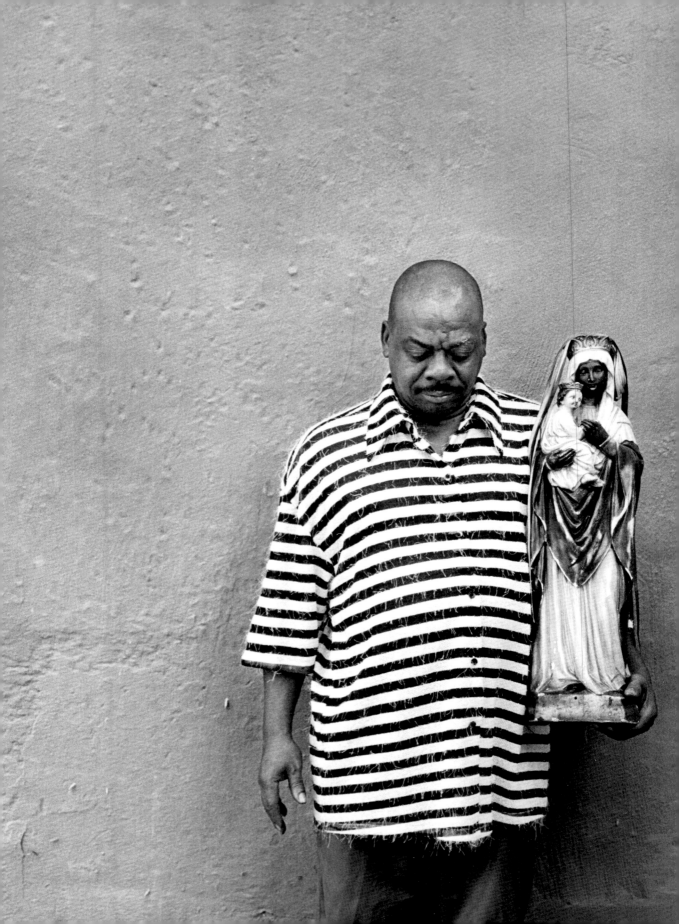

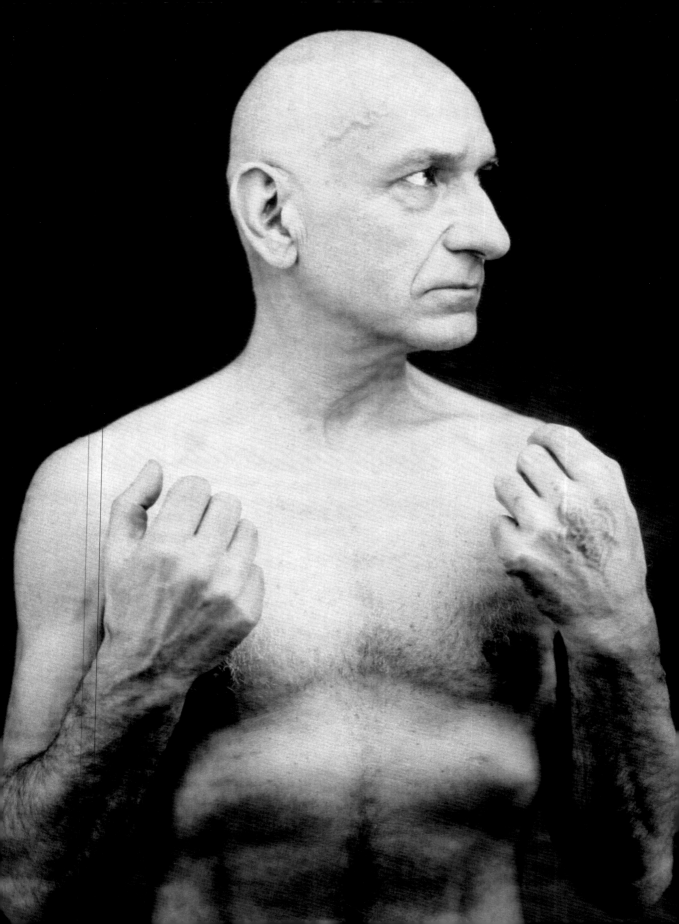

To offer to our tribe, as storytellers, narratives which are absent of a dark side is a terrible disservice. I'm just fighting for the right for a film to be stirring and brilliant and illuminating.

—Sir Ben Kingsley, 60

Life has frightened me now and then, and if I've ever shown uncommon bravery, I've failed to notice it. I still dream big at times.

—Gordon Parks, 90,
and mentee

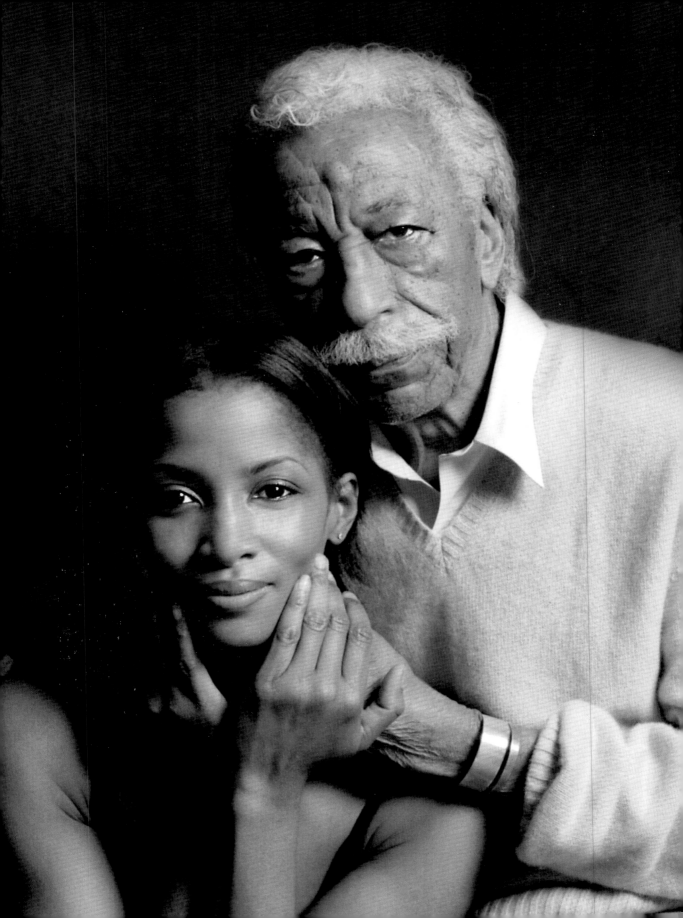

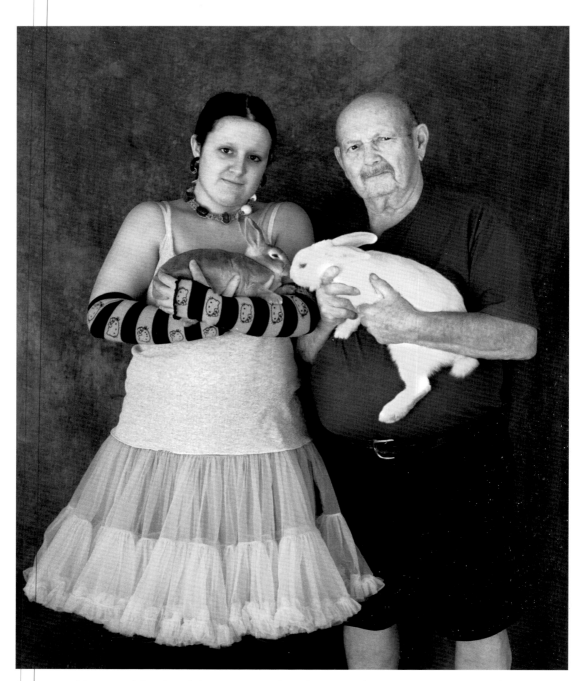

I raise rabbits and birds. I love to see the pleasure they give young people. It's impossible to feel unloved while you're cuddling a rabbit.

—Fred Hatch, 77,
and friend

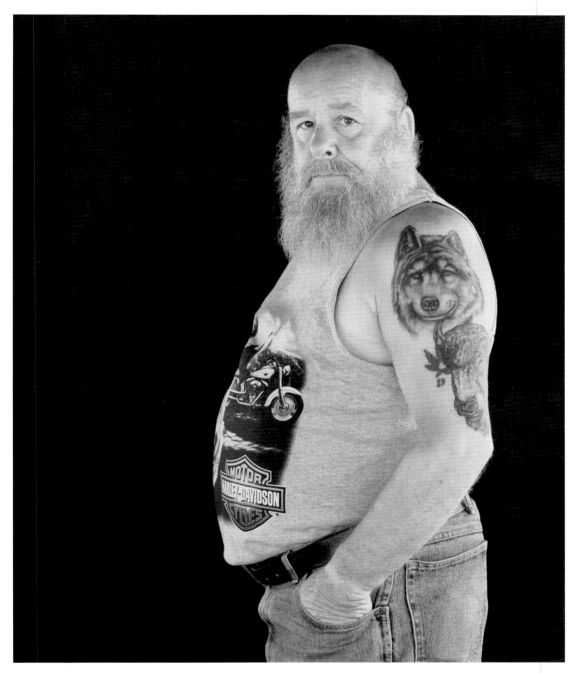

The wolf and buffalo tattoos are symbols of great American animals that have survived. They are freer now than men.

—Allan Thibodeau, 60

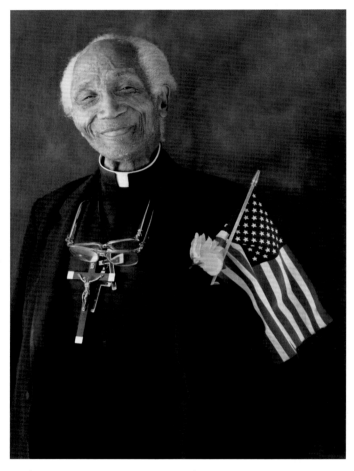

I always say I'm sixteen. I don't want to retire, I'm not going to any cemetery, I'm living! I was educated at the Tuskegee Institute, but I still take classes every semester. We all took ROTC training at Tuskegee, and ever since I've carried a flag. I'm proud of this flag because so many have died for it, and no matter what anybody says, it's the best country in the world to live in.

—Reverend A.D. Robinson, 90s

I laid bricks for forty-six
years. I saved my money,
but it wasn't doing that
well in the bank, so I
invested in toys like my
1917 Oldsmobile. It's
worth about $40,000. The
duster I'm wearing is an
original. They wore these
in the 1920s because the
cars didn't have windows
and your clothes got dirty.
I enjoy exhibiting my car in
shows around Montana.

—Wesley Tintinger, 66

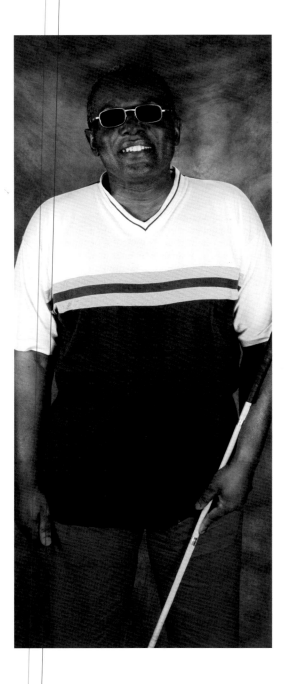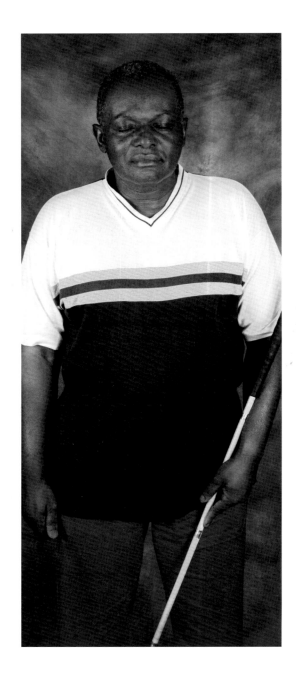

My grandson bought me these sunglasses. He says he doesn't want me to look like an "old man." I was a sheet-metal worker and almost fell off the twenty-ninth floor of a building before I realized I was losing my sight. I was forty-seven when I went totally blind. I don't feel sorry for myself. I am just happy to be alive.

—Irving Hart, 61

I've had a grain farm since 1940. I like going out in the field and not being accountable to nobody. Politicians stir me up pretty bad — the present ones are the worst scallywags ever.

—Frank Nickol, 81

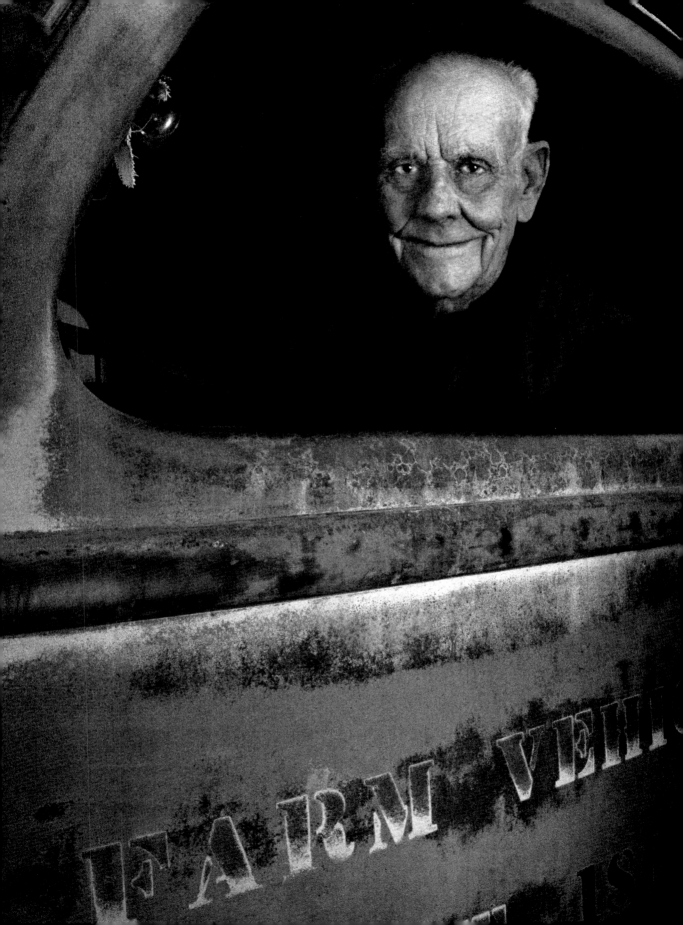

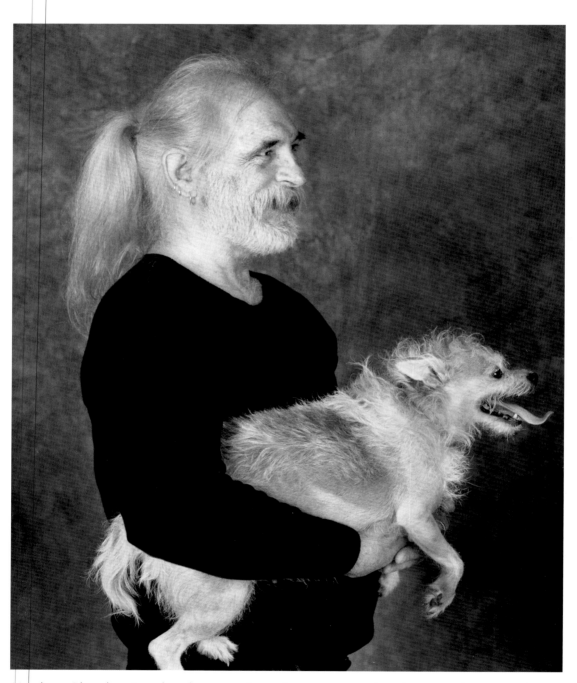

My dog, Blanche, is a loyal companion. I never wanted to live in a big city. I create art as a way of life, as a reward in itself. Hustling is not a part of my philosophy.

—Jeff Raymond, 61

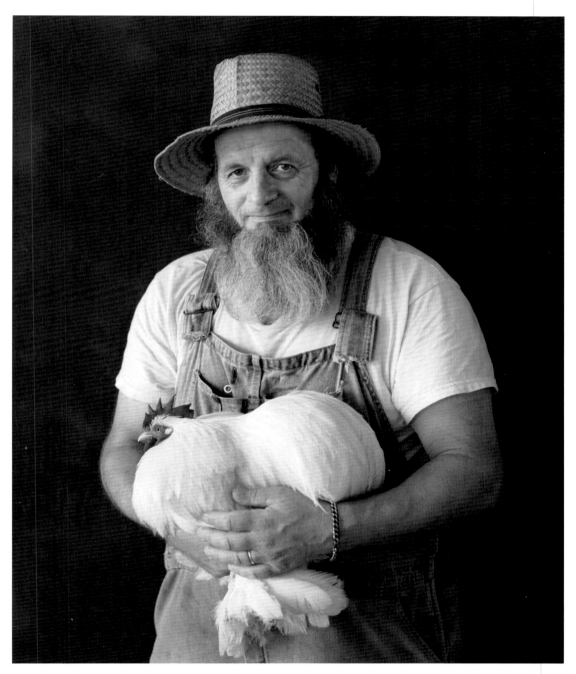

This white bantam won the blue ribbon. I guess you could say he is a champion cock. His feathers and form are perfect.

—Larry Peaslee, 60

I've found men often need a muse to help them access their own creative souls. The *Helga* pictures caused a lot of controversy when the book came out in 1991. People were more interested in whether I had been having an affair with Helga than looking at the paintings. They are still asking.

—Andrew Wyeth, 86

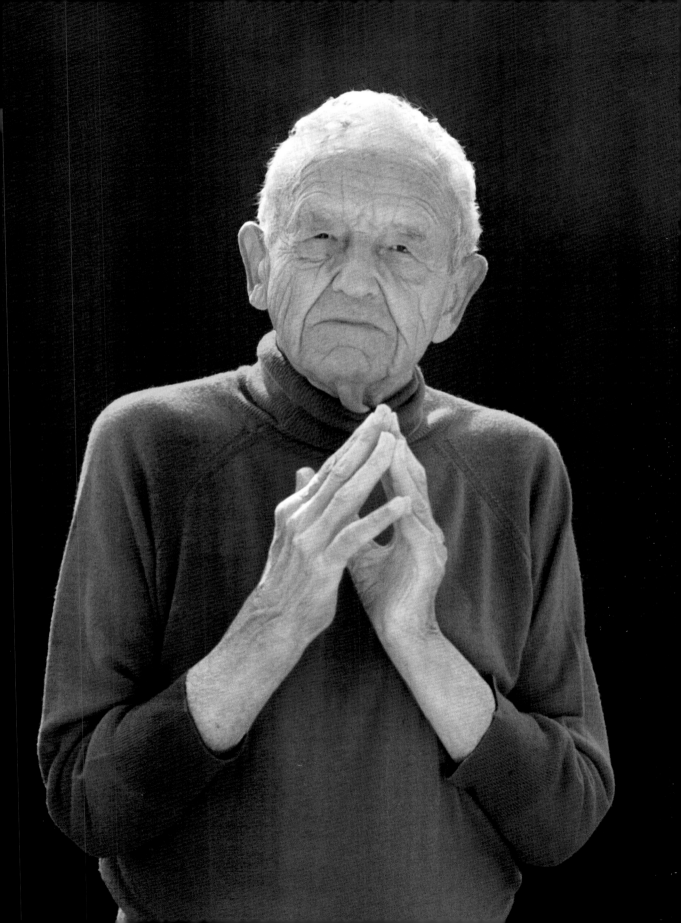

I see the world differently at age seventy-five. My grandson
Fraser, who is only six, has taught me to look at the small
things in life more closely. Being a grandfather is much
easier than being a father.

—John Metcalf, 75,
and grandson

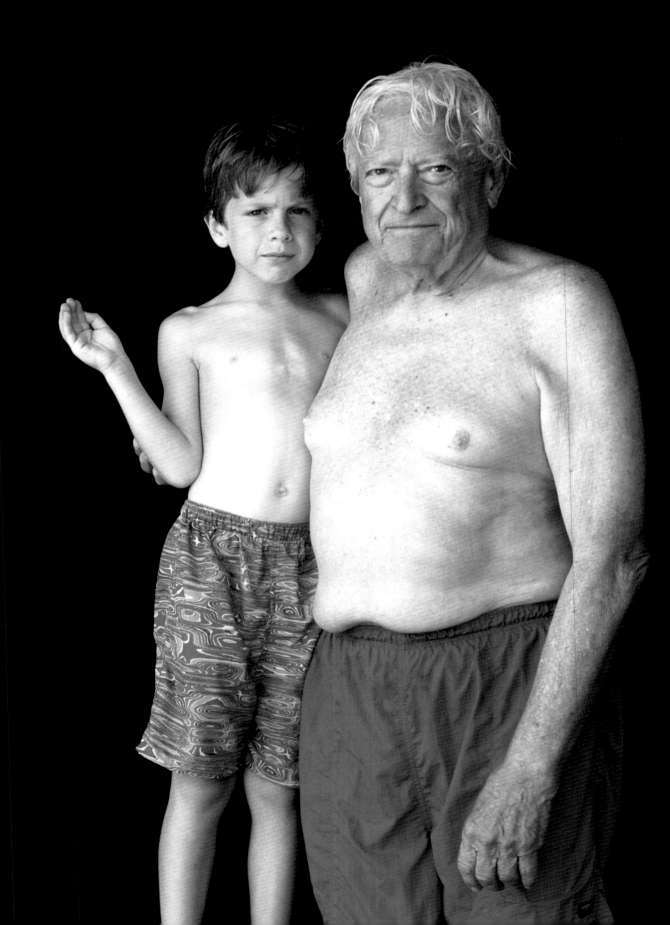

LIST OF PLATES

BEHIND THE SCENES

(photographs on pages 5, 7, and 8)

1. Joyce with New York City firefighters and Museum Director John Neff: photograph by Lisa Devlin 2. Joyce with Mario Andretti in Pennsylvania: photograph by Mitch Soileau 3. Joyce with Octave Finley in Montana: photograph by David Jones 4. Joyce with Doc in Las Vegas: photograph by Sharon Sampsel 5. Joyce with Robert Indiana in Maine: photograph by Mitch Soileau 6. Joyce with Khing Oei and Jeannie MacPhearson: photograph by Matthew B. Carasella 7. Joyce with Clotaire Bazile in Miami: photograph by David Jones.

ACKNOWLEDGMENTS

I would like to thank all of my wonderful assistants, friends, family, and sponsors. This book involved an enormous amount of research, travel, and planning. Many people helped me uncover the "amazing men" I photographed in large cities and small towns across the country. I am particularly indebted to the following:

Location facilitators:
Atlanta, GA: Dr. Johnnetta Cole, Fay Gold; *Camden, ME:* The Maine Photographic Workshops, Maggie Blanchard, John Paul and Alexandra Caponigro; *Columbus, OH:* Nanette Hayakawa, Stephanie Hightower, Richard Petry; *Delaware:* Sally Packard, Dinah Reath; *Las Vegas, NV:* Greg Preston and Sharon Sampsel; *Los Angeles, CA:* Carole Black; *Miami, FL:* Daniel Azoulay, Mireille Gonzales, Tom Lopez, Joan Rosenberg; *Montana*: Donnie Sexton; *New York:* Isisara Bey, Tom Caravagalia, Eve Ensler, Beth Filler, Annette Innsdorf, Paul Kleyman, Pat Mitchell, Paula Perliss, Matthew Jordan Smith, Sally Susman; *Philadelphia, PA:* Jim Graham; *Santa Fe, NM:* Reid Callanan, Renie Haiduk, Alan Thornton; *Savannah, GA:* Chercy Lott; *Washington, DC:* Danny Conant Frank Grisdale

The great people at Bulfinch Press:
Matthew Ballast, Jill Cohen, Maureen Egen, Adrienne Moucheraud, Karen Murgolo, Margaret Pai, Michael L. Sand, and Pamela Schechter

Assistants:
Lisa Devlin, Mitch Soileau

Interns:
Duffy-Marie Arnoult, Kat Barthelme, Ronnie Beach, Chris Cognazzo, Paula Davis, Bridget Finn, Regina Fleming, Bryan Ghiloni, Sarah Glazer, Lara Kimmerer, Sarah LaVigne, Tim Lisko, Gray Lyons, Megan Marascalco, Zoe Nelson, Christina Richards, Erin Sanders, Wendy Schlichting, Megan Senior, Diana Teeter, Linda Wilson, Kathleen Wright

Sponsors:
Julieanne Kost, Adobe Systems, Inc.; Dave Metz, Canon U.S.A.; Terry Monahan and Peter Poremba, Dyna-Lite, Inc.; Dan Steinhardt, Epson America; Cliff Hausner and Mark Rezzonico, Leaf America; Bob Finucane, Hasselblad U.S.A.; Mark Duhaime, Imacon, Inc.; Audrey Jonckheer and Jeff Gunderman, Eastman Kodak Company

Family:
Also a big thank you to my family: Alex and Kate Cohen, David, Jo, Jessie, and Margaret Jones, and Anne and Jack Doyle, who had to put up with my consuming passion for this project, which often meant long hours that cut into my time with them.

Special thanks to Paula Davis, Chris Cognazzo, and Michael Goesele, who designed the book along with creative director Miwa Nishio. We are also grateful for the support of the faculty at Savannah College of Art and Design.